PRINCIPLES OF

COLOR DESIGN

WUCIUS WONG

PRINCIPLES OF

COLOR DESIGN

SECOND EDITION

JOHN WILEY & SONS, INC.

New York Chichester Weinheim Brisbane Singapore Toronto

Cover and interior design: Wucius Wong.

This book is printed on acid-free paper. ☉

This publication is designed to provide accurate and authoritative information in regard to the subject matter covered. It is sold with the understanding that the publisher is not engaged in rendering professional services. If professional advice or other expert assistance is required, the services of a competent professional person should be sought.

Library of Congress Cataloging-in-Publication Data:

Wong, Wucius.
 Principles of color design/Wucius Wong.—2nd ed.
 p. cm.
 Includes index.
 ISBN 0-471-28708-3
 1. Color in design. I. Title.
NK1548.W66 1996 96-8346
701'.85—dc20

Printed in the United States of America

10 9 8

This book is dedicated to

Dr. Joseph V. Canzani

my first teacher in color

CONTENTS

PREFACE

Numerous books on color have been published. Some treat the subject as a kind of science, making it too technical for comprehension by the designer or any common reader. Some concentrate on the use of oil or acrylic paint and are strictly for artists. Some contain page after page of color guides with little coverage of color theories. Some describes computer procedure of originating and reproducing color images, with exclusion of using pigments for design visualization.

The first edition of this book was written some eight years ago, aiming to introduce principles of color harmony in a simple language. It offered a fresh look at popular color theories, stressed systemic color thinking, discussed basic concepts of design, and included many examples of exercises to help the beginner acquire a solid foundation in design and develop a personal color sense. That edition was restricted to the use of pigments for hand-painted compositions.

Over the period, the rapid development of computer technology and the wide adaptation of computer use in the graphic and other design professions and in education have greatly changed our ways of conceiving, creating, specifying and using colors. This necessitates a revision and expansion of the earlier text, to extend from the application of color pigments to the use of computer-generated colors in design.

Here two new parts have been added to the three parts of the first edition. This new edition, rectifying much of the shortcomings of the earlier text, bridges the gap between the traditional way of using color as pigments, to the most recent way of visualizing color as light displays in the information age. It includes introduction to color lights and color printing, computer techniques of color creation and adjustment.

Furthermore, it contains a set of color guides demonstrating new and efficient ways of attaining color harmony as facilitated by the computer. As color alterations can be implemented with easy operations, designers of all disciplines can easily develop their own color schemes from the color guides for their own use.

A total of five parts make up the present book. Part I tackles the design principles that help a design beginner create his or her own designs for color experimentation. Part II examines common color principles related to the use of color pigments. Part III presents examples of hand-painted exercises in color and design. Part IV introduces computer principles and techniques, and the use of color on the computer.

Part V comprises color sets and guides accompanied with explanatory text for attainment of color harmony.

Although the present book is intended as an independent volume, it complements my other book, *Principles of Form and Design*, in which a thorough discussion of visual grammar and vocabulary can be found, with extension of design thinking from two dimensions to three dimensions.

Grateful thanks are due to Adobe Systems, Inc., for the provision of the latest versions of Adobe Illustrator and Adobe PageMaker, and to Macromedia, Inc., for the latest version of Macromedia FreeHand. All the illustrations and guides in Parts IV and V were created either with Adobe Illustrator, Adobe Photoshop, or Macromedia FreeHand. Adobe PageMaker was used for the overall layout design of the book.

Dr. Joseph V. Canzani, president emeritus of the Columbus College of Art and Design, Columbus, Ohio, was an inspiring teacher who first initiated me into the realm of color and design. I still remember vividly his lectures and critiques that took place more than three decades ago. It is to him this new edition is dedicated.

W.W.

PART I : DESIGN PRINCIPLES

PART I : DESIGN PRINCIPLES

INTRODUCTION

The design principles covered in this Part relate to discussions of color design in the later portion of the book. This is not a comprehensive examination of design, but rather a brief discussion of some common terms and basic principles governing designs with color. My purpose is to present a few essential ideas and criteria that can be effectively applied to a variety of visual situations.

Design can be seen as the visual expression of an idea. The idea is conveyed in the form of a composition. Shapes—their sizes, positions, and directions—make up the composition to which color scheme is introduced.

In this Part, the basic elements of design- planes, lines, and points- are considered. The design area is divided into planes, and planes are subdivided into lines and then points in a series of black-and-white illustrations that introduce the ways in which students can experiment with compositions.

Formal and informal compositions are examined. Formal compositions are created with the simple mathematical concepts of translation, rotation, reflection, and dilation. Informal compositions are accomplished by considering gravity, contrast, rhythm, and center of interest. This Part ends with a close consideration of space and volume.

The illustrations were created with thin vinyl sheet material with self-adhesive backing. This material can be easily cut into rectilinear shapes and strips with a mat knife. The shapes or strips can be arranged and rearranged on a white surface before they are burnished down to form a permanent adhesion. The final effects of designs can thus be previewed, without preliminary sketches. Alternatively, black paper and rubber cement can replace the vinyl sheets, but compositions created with rubber cement are more difficult to alter.

PLANES

4

A design area is an uninterrupted space defined by edges. Because a square format is used here, there are four edges of equal length that form four right angles. This uninterrupted space is then divided into sixteen equal parts. If this square is colored black and the uninterrupted space is the white surface of paper, a black plane on white ground results (fig. 1).

The square can be moved up or down, with its edges remaining parallel to the vertical and horizontal edges of the design area. This movement produces a change in *position.* The square can also be tilted, so its edges are no longer parallel to the vertical and horizontal edges of the design area, which produces a change in *direction.* Changes in position and direction can be effected simultaneously.

Design decisions include the determination of positions and directions. The decision to use a square and the number of squares used may be given conditions, or may also be design decisions. When shapes overlap one another, several visual options emerge: they may be joined (fig. 2); they may be separated by a thin white line, so one shape appears to be in front of the other (fig. 3); the overlapped area becomes white (fig. 4); one shape covers a portion of another, making the overlapped part invisible—as if part of the black shape were removed (fig. 5).

Figures 6 through 9 demonstrate the use of squares as planes in design.

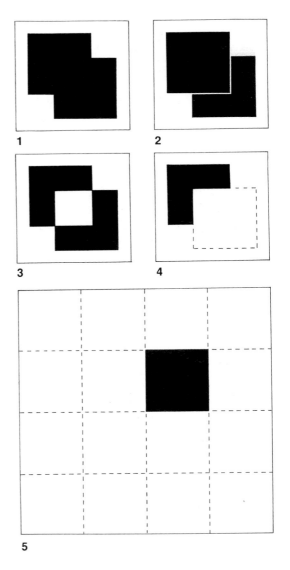

1

2

3

4

5

Planes in Design

6

7

8

9

LINES

The square shown in figure 1 can be divided into three equal parts. Each part becomes a small elongated shape, or a *line* (fig. 10).

A line is directional; it has length but no breadth. It divides or encloses an area. It is at the edge of a shape. When breadth is present, a shape emerges. However, shapes of some length and narrow breadth are generally seen as lines, which can have:

 a. smooth or rough edges (fig. 11)
 b. squared, rounded, or pointed endings (fig. 12)
 c. a solid or textured body (fig. 13)
 d. curves or be straight in direction (fig. 14).

The shape that is defined in figure 10 and used in figures 15 through 18 is a short line with smooth edges, squared endings, a solid body, and a straight direction. Its length can be extended by joining it to, and letting it overlap, another line. The different ways of overlapping a shape, as described in figures 2 through 5, apply to lines as well.

The squared endings impose some restrictions. For instance, when two shapes are joined at the endings, they cannot form an acute angle without exposing the right-angled corners.

Figures 15 through 18 show how the line in a given shape is used in different ways. Figure 16 features some planes formed by the joining of lines.

10

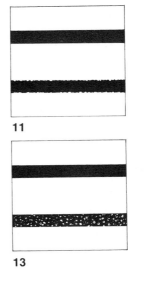

11

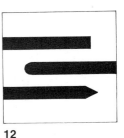

12

13

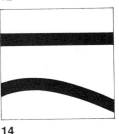

14

Lines in Design

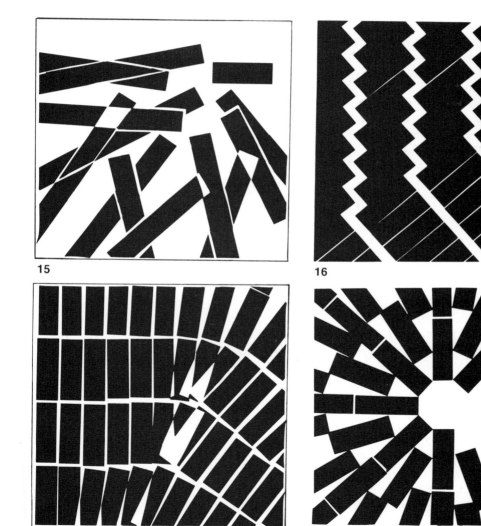

15

16

17

18

POINTS

Division of the short line in figure 10 into three equal parts creates three small squares, which can be considered *points*, because they take up a relatively small portion of the design area (fig. 19).

Actually, a point denotes position alone; it should not have any length or breadth, or cover any area. This square point is a plane in miniature. Again, all the different ways that shapes can be overlapped (described in figure 2 through 5) can be applied to these points.

Most people tend to visualize points as round shapes that do not exhibit a direction when taken individually. Square points with their right-angled corners do show direction. Directions can also be established when the points are lined up or are positioned to suggest hidden lines (fig. 20).

Figures 21 through 24 are examples using numerous points as small shapes in design.

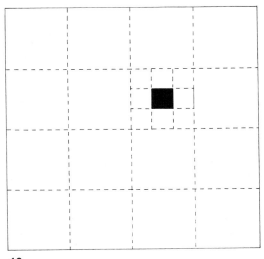

19

20

8

Points in Design

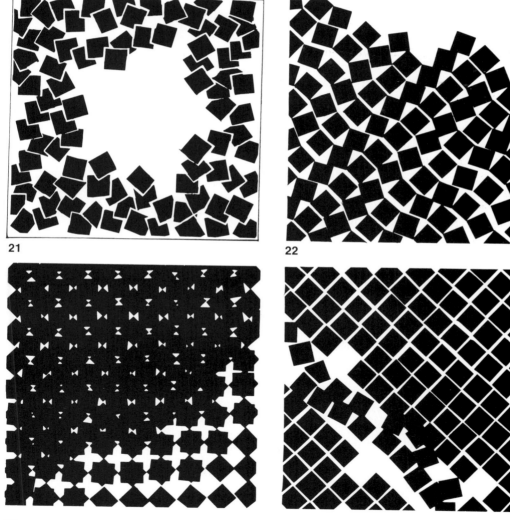

21

22

23

24

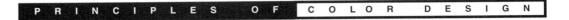

FORMAL COMPOSITIONS

A formal composition generally contains an underlying mathematical structure that rigidly governs the positions and the directions of elements. Rules are predetermined; nothing is left to chance. Elements are either arranged in repetition, or according to shape, size, position, direction, and/or color.

A formal composition does not always become a pattern. Overall patterns, however, are invariably based on formal compositions—the occurrence of a group of forms is predictable.

Slight deviation from the rigid rules of a formal composition results in a *semiformal* composition, which contains anomalous elements, or loosely follows the predetermined rules.

The four ways of producing formal compositions are based on mathematical concepts of symmetry. Their combined use can lead to numerous variations. These include:

 a. *translation,* or the change of position (fig. 25)

 b. *rotation,* or the change of direction (fig. 26)

 c. *reflection,* or creating a mirror image of the shape (fig. 27)

 d. *dilation,* or the change of size (fig. 28).

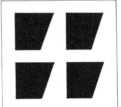

25

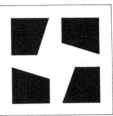

26

27

28

Translation

The translation of a shape changes its position. The direction of the shape, however, remains unchanged.
Translation is the repetition of shape in a design. In formal compositions, translated shapes are regularly spaced.
Translations can be vertical (fig. 29), horizontal (fig. 30), diagonal (fig. 31), or a combination of these (fig. 32).

The distance between shapes can be measured, once a satisfactory arrangement is obtained, by using one corner of the shaped as a guide. This results in a structural grid, which serves to regulate the final design (fig. 33).

Figure 34 illustrates planes in translation.

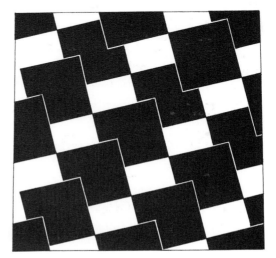

33

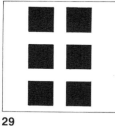

29

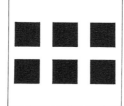

30

31

32

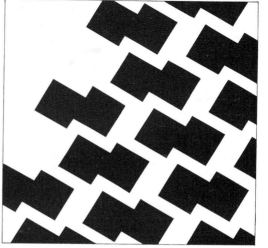

34

Rotation

The rotation of a shape results in a change in its direction. In most cases, rotation also results in a change of position, so rotated shapes are not superimposed.

Shapes radiate when they are rotated regularly about a center of reference. Each shape should be positioned on an imaginary axis, at equal distance from the *center of reference,* before rotation is effected.

Figures 35 through 38 show how four shapes are arranged in a ninety-degree rotation, resulting in formal compositions. (Broken lines represent axes, and points represent centers of reference in these diagrams.)

Figure 39 is a finished design composed of lines in rotation.

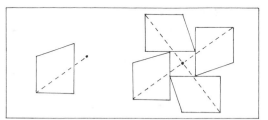

35

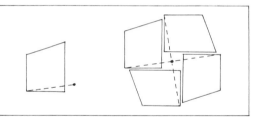

36

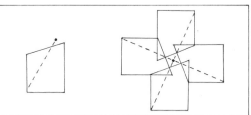

37

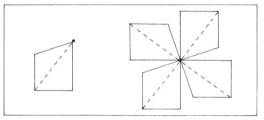

38

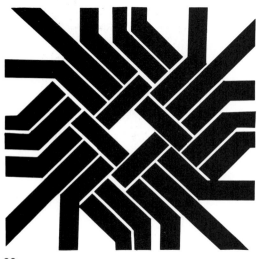

39

12

Reflection

Dilation

The reflection of a shape or a group of shapes can result in *bilateral symmetry* (a mirror image of the original shape or shapes). The original shape must be asymmetrical, because the mirror image of a symmetrical shape is no different from the original. The overall shape of a group of shapes to be reflected should be asymmetrical as well. Reflected shapes can also be translated and rotated (fig. 40).

Dilation effects changes in the *size* of shapes. The dilation of a shape that is not translated produces a regular, concentric design (fig. 41).

Dilation can be used to suggest movement of shapes forward or backward in space: smaller shapes appear to be farther away; larger shapes seem closer to the viewer.

13

40

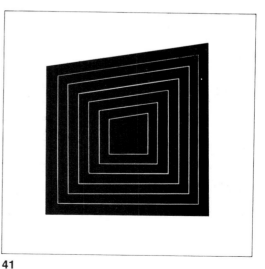

41

INFORMAL COMPOSITIONS

Informal compositions do not depend on mathematical calculations, but on an eye sensitive to the creation of asymmetrical balance and general unity with freely arranged elements and shapes.

No definite procedures exist, but the following may be used as criteria for evaluating informal compositions:

 a. gravity—the weight and balance of shapes (fig. 42)

 b. contrast—the visual (characteristics of shape and color), dimensional, or quantitative differences that distinguish one shape, part of a shape, or group of shapes from another shape, another part of the same shape, or another group of shapes (fig. 43)

 c. rhythm—the suggested movement and velocity, similar to melodic developments in music (fig. 44)

 d. center of interest—a focal point that either catches the viewer's eye or defines the place of convergence, divergence, or climax of rhythmic forces (fig. 45).

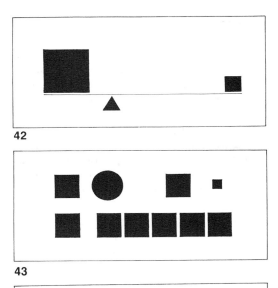

42

43

44

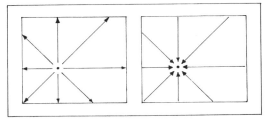

45

Gravity

A designer manipulates how the weights of shapes are perceived by the viewer. Dark shapes among lighter ones on a white background, large shapes among smaller ones, tend to appear heavier. In addition, all shapes seem to be subject to a gravitational pull toward the lower edge of a design.

Gravity affects the balance of elements in a composition. Heavy shapes could be balanced with light shapes, one shape with a group of shapes. A perfectly balanced design, with each shape in its proper place, would be upset by an addition, subtraction, or the transposition of a single shape. It might also seem out of balance when viewed sideways or upside-down.

The effects of gravity can also be approximated to create stable and unstable shapes. Stable shapes have wide bases that are parallel to the bottom of the design. Unstable shapes have pointed or narrow bases. Stable shapes can be tilted to appear less stable; unstable shapes can become stable with the support of other shapes.

46

47

Contrast

Contrast is the comparison of dissimilar elements and helps to identify shapes and enhance visual variety in a composition. Aspects of contrast include not only shape, size, color, and texture, but also position, direction, and spatial effects. The quantity of shapes used and their density also affect contrast.

The antonyms heard in everyday communication can inspire the use of contrast in design: straight, crooked; square, round; protruding, intruding; sharp, blunt; regular, irregular; large, small; long, short; light, dark; brilliant, dull; rough, smooth; positive, negative; perpendicular, oblique.

In most cases, contrast is subconsciously introduced as shapes are created and arranged. Contrast is also intentionally introduced where visual emphasis is needed; insufficient contrast can result in a flat, uninteresting design. Too much contrast, on the other hand, can damage the overall unity of the design.

Contrast should generally be most apparent at the center of interest. However, it should not be introduced as an afterthought, but emerges naturally during the process of creating the design (figs. 48, 49).

48

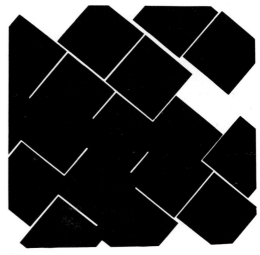

49

Rhythm

A representational design often describes a subject or theme, whereas abstract designs are frequently inspired by an idea—an event, movement, or a natural phenomenon that can be rhythmically expressed.

We are surrounded by rhythms that can be expressed as designs: ripples on a lake; birds in flight; trees spreading their branches; flowers in full bloom; clouds moving across the sky; sand scattering on a beach; a fountain spurting water; waves pounding on rocks; the bounce of a ball; an explosion of dynamite.

Abstract designs that are inspired by such ideas are not merely decorative. More important than whether or not the idea is apparent to viewers is the spirit and rhythm with which the design is infused. In addition, the idea reflects a designer's personal vision and may foster creativity.

Rhythm is generated by manipulating the directions of and spaces between elements, which may be parallel, similar, contrasting, or radiating (figs. 50–53). Wide and narrow spaces between elements suggest the velocity of movement. (fig. 54).

50

51

52

53

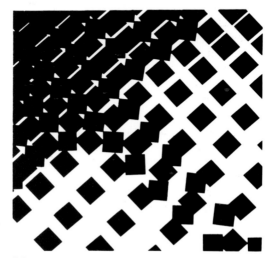

54

Center of Interest

An informal composition must coordinate its elements around a center of interest—an area where all elements originate, cease, or interact, providing the visual drama without which the design becomes a mere conglomeration of parts (fig. 55).

A formal composition, on the other hand, does not necessarily include a center of interest, particularly if there is an overall pattern based on regular translation. A radiating design based on rotation, however, will have an obvious center of reference, and central axis underlies designs of bilateral symmetry based on reflection. When an anomaly is introduced into a formal design, it usually becomes the center of interest of what becomes an informal composition (fig. 56).

Although a center of interest may appear in almost any part of a design, it tends to make the design static at the geometrical center; if placed at one of the four corners of a square or rectangular design, the uneven distribution of weight can upset the balance.

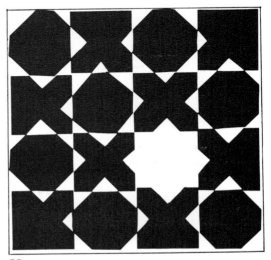

55

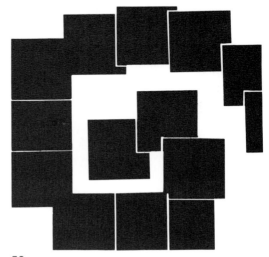

56

18

SPACE

Designs begin as blank areas that are then activated, filled, or transformed by elements. Occupied space is usually called positive, unoccupied space is called negative space (fig. 57). The negative space between positive shapes can either be wide or narrow (fig. 58).

A negative shape can represent a solid shape that is the color of the background (fig. 59).

Space that is divided by an invisible line can result in:

a. shapes cropped by the line (fig. 60)

b. positive shapes that become negative on the other side of the line (fig. 61)

c. shapes that shift position and/or direction on the other side of the line (fig. 62)

d. the occurrence of different visual elements on the other side of the line (fig. 63)

e. positive shapes that change at the line (fig. 64)

57

58

19

59

60

61

62

63

64

The Illusion of Depth in Space

A space appears to have depth when one shape overlays, but is not joined to, another. When the two shapes are the same size, the sense of depth is rather limited (fig. 65).

The illusion of greater depth can be achieved with various sizes of the same shape, as a larger shape appears to be closer to the viewer than does a smaller shape (fig. 66).

An illusion of depth can also be created by laterally turning a shape in space. A square is thus transformed into a rhombus, parallelogram, or trapezoid (fig. 67).

When lines in a sequence are bent, curved, twisted, or looped, an illusion of depth always results (fig. 68–71).

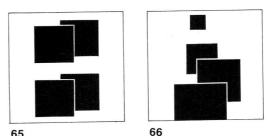

65

66

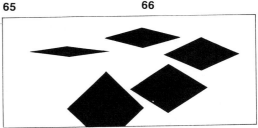

67

68

69

70

71

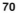

20

The Illusion of Volume in Space

Volumes result when planes curve to form cylinders, or when places are joined from different directions, and seem to enclose space. Planes may be solid, a sequence of lines or points, outlined, or created with a combination of these methods (figs. 72–75).

Volume construction can produce ambiguous compositions: a plane might seem to face up and down, depending on how it is viewed, and it can be part of two adjacent cubes that are seen from different angles (fig. 76).

The same cube can be arranged at different angles to form an interesting design (fig. 77).

72

73

74

75

76

77

PART II : COLOR PRINCIPLES

PART II : COLOR PRINCIPLES

INTRODUCTION

All we see around us is the effect of light which enables us to distinguish one object from another, or from its surroundings. Light is a kind of energy that reaches the optical nerve system of our eyes, directly or indirectly, and is interpreted by our brain as color. This energy emits from a light source, but may have been filtered through transparent or translucent matter, partially absorbed and partially reflected from a surface, before it is *seen*.

The sun is the main light source in nature. Its illumination sets the standard of our color perception. There are other light sources too, natural as well as artificial. The same object could appear in a different color with change of light source, or when the light source is modified. We can alter the color of an object by coating it with pigments.

We can create any specific color with artificial color lights, or with pigments manufactured from plants or minerals. Using color lights requires special equipment and often confined situations and environments. Pigments, however, are commonly available to us in various ready-made substances or tools, such as pencils, pastels, felt-tip markers, drawing inks, watercolors, gouaches, poster colors, acrylic colors, oil paint, house paint, dyes, etc.

As most of us are more familiar with pigment colors than with color lights, in this Part I shall initially confine to color principles that are primarily related to the use of color pigments. Such principles will echo theories put forward by Johann Wolfgang von Goethe, the great German poet of the late 18th and early 19th centuries, who made important discoveries in the realm of color, and particularly Albert H. Munsell, a highly influential American colorist of the 20th century, who clearly defined color in three main aspects.

Our study of color will first take a more traditional attitude, based on our common notions of what color is, our experience with color as tangible powder, pastes, or liquids that can be physically manipulated or intermixed, and our drawing and painting activities.

Discussion of color lights, color printing, and the use of computer to create colors will take place in Part IV where a more scientific attitude will be adopted.

BLACK AND WHITE

Black, the darkest possible color, is most effectively applied to a surface, as it obliterates what originally covered it. White, the lightest possible color, is also opaque, but must be applied thickly in order to cover a surface. It is ideal, however, as a surface for receiving colors, for it can show the faintest stains and does not distort colors, though it slightly darkens them. Neither black nor white can be produced by mixing other pigments.

Black and white used together create the greatest tonal contrast with maximum legibility and economy of means. They are therefore ideal for sketching, drawing, writing, and printing. In most instances, black makes the mark, and white is the surface, accounting for the tendency to read black shapes as positive and white shapes as negative spaces.

Since we are more accustomed to black images on a white background, reversing the two colors suggests something unreal, sometimes creating a dense or heavy design (figs. 78, 79).

78

79

Flat Tones with Black and White

A uniform texture can be made with
black on white or white on black, result-
ing in a flat tone that is either light or
dark, depending on the proportion of
black to white areas in the combination
(fig. 80).

The same effect can also be achieved
with fine black-and-white patterns, con-
sisting of a regular arrangement of tiny
planes, lines, or points.

In figure 81, the black-and-white ele-
ments are optically mixed and perceived
as gray.

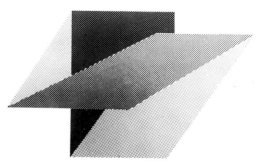

80

27

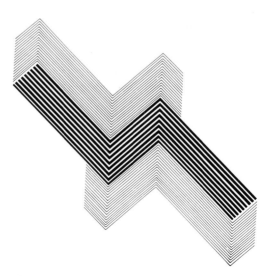

81

Tonal Transitions with Black and White

A black-and-white pattern consisting of lines or points can show a gradual change in density, subtly lightening or darkening the pattern from one part to another (fig. 82). A black-and-white texture, not necessarily as regular as a pattern, can produce a similar effect.

Although illusions of volume and depth can be achieved with black and white producing flat tones, much finer illusory effects are obtained with varying densities creating complicated areas of tonal transitions (fig. 83).

82

83

NEUTRAL COLORS

Mixing black and white pigments in varying proportions produces a range of grays. These grays together with black and white are referred to as *neutral colors*.

Although numerous steps of gray are possible, it is simpler to create only nine and arrange them into three groups.

The dark gray series consists of:
1. extremely dark gray (90 percent blackness)
2. very dark gray (80 percent black ness)
3. dark gray (70 percent blackness)

The middle gray series consists of:
4. dark middle gray (60 percent blackness)
5. middle gray (50 percent blackness)
6. light middle gray (40 percent blackness)

The light gray series consists of:
7. light gray (30 percent blackness)
8. very light gray (20 percent blackness)
9. extremely light gray (10 percent blackness).

These nine steps provide a basis for the accurate systematization of color. A chart comprising the steps is called a *gray scale.* Black and white are not shown, because the scale provides light-dark comparisons to various colors, and no color is as dark as black or as light as white. Black can be given the number 0, meaning the total absence of light, and printed with 100 percent blackness, and white the number 10, meaning the maximum amount of light, and printed with 0 percent blackness.

This standard scale is a guide to visual thinking. Judging values with the naked eye can be inaccurate, since we tend to distinguish more gradations in the range of light grays than dark grays.

To obtain the grays that constitute the scale, black and white pigments can be mixed in varying proportions. The gray scale in figure 84 was produced with a mechanical device and features machine-printed halftones; black and white pigments were not physically mixed.

Gray Scale

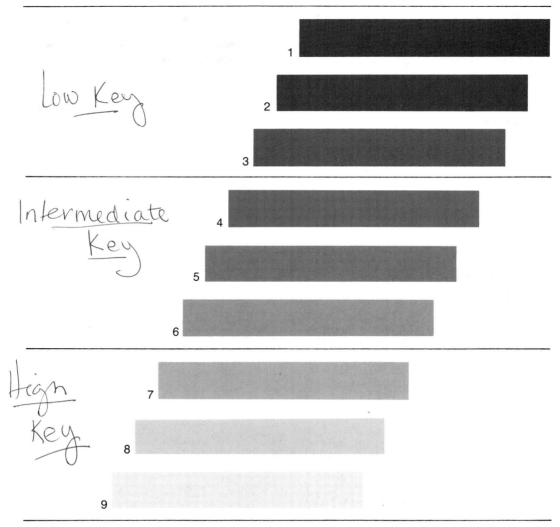

Low Key

1
2
3

Intermediate Key

4
5
6

High Key

7
8
9

30

Specific Keys of Neutral Colors

Grays are far more effective in suggesting depth and volume than black and white, which must be applied as textures and patterns to express the densities and weights of shapes and areas (fig. 85).

The terms *high key, intermediate key,* and *low key* denote particular tendencies toward specific effects. The application of neutral colors can be limited to a particular key, which emphasizes one portion instead of the entire scale.

High key describes a general lightness in the tonal expression of a design and stresses the light-gray series (see fig. 84, steps 7, 8, 9) extending to white.

A design that exclusively features white and light grays creates a sense of mistiness and overall softness (fig. 86).

Some darker grays can be introduced for contrast, distinguishing between the expressed forms. This, however, cannot be overdone or the high-key effect will be destroyed.

85

86

Neutral colors in an intermediate key are, for the most part, in the middle-gray series (see fig. 84, steps 4, 5, and 6). A design that is restricted to middle grays often lacks sparkle. A small amount of light and dark gray can add variety to the design (fig. 87).

Effective use of the intermediate key results in a well-balanced, intelligible composition.

Dark grays predominate in a low-key design, featuring the shades of gray in steps 1, 2, and 3 of the scale illustrated in figure 84. The design can also include transitions between these grays as well as black (fig. 88).

Shapes in a low-key design can be articulated and contrast introduced by adding lighter grays. This must be done subtly if the effect of a low-key design is to be maintained.

87

88

CHROMATIC COLORS

Same color – Extensions of color

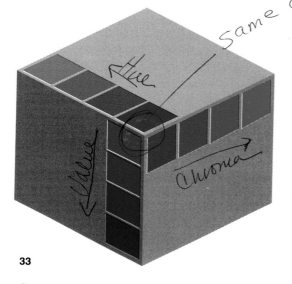

33

Our common notion of color refers to the *chromatic* colors, which relate to the spectrum as can be observed in a rainbow. Neutral colors are not part of these and can be referred to as *achromatic* colors.

Each chromatic color can be described in three main aspects. *Hue* is the attribute that permits colors to be classed as yellow, blue, and so on. The description of a hue can be more precise by identifying the color's actual inclination from one hue to the next. For instance, a particular red may be more accurately called *orange-red*. Different color systems use different codes made up of letters, numbers, or a combination of both, to describe colors.

Value, or *brightness*, refers to the degree of lightness or darkness in any color. A color of known hue can be more accurately described by calling it either *light* or *dark*. For instance, a red is said to be light red if it is lighter than our notion of a standard red.

Chroma, or *saturation*, indicates the intensity or purity of a color. Colors with strong chroma, or colors of full saturation, are the most brilliant, most vivid colors that can be obtained. Colors that are desaturated have weak chroma; they are dull or muted, and contain a large proportion of gray.

Figure 89 shows the three main aspects of color—hue, value, chroma—as the three dimensions of a color cube. They also resemble the letter Y in the illustration: the vertical stroke is the extension in value; the upper-left stroke is the extension in hue; and the upper-right stroke is the extension in chroma. The color swatches immediately surrounding the central Y are identical (a green hue of middle value and moderate chroma). The colors move from green to yellow-green in the hue extension, from middle to dark in the value extension, and from grayish to full saturation in the chroma extension.

33

Figure 90 maps the value and chroma of a single hue—a yellowish green. Each horizontal row represents one value level of the hue in a gradation of chroma, from low saturation on the left to high saturation on the right. Each vertical row represents the hue with similar saturation in a gradation of value, from high value at the top to low value at the bottom. Some rows are shorter, because the chroma of that particular value step in the sequence can proceed no further.

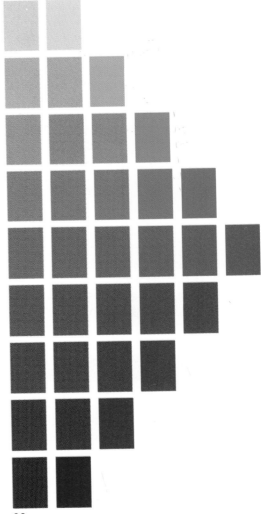

90

VALUE – *light or dark*

The first step in the exploration of color is to use all the possible variations of a single hue. As we have seen in figure 90, by manipulating its value or chroma, a single hue can comprise a range of over twenty colors; additional transitions between colors can always be introduced. Since our vision can easily distinguish between lightness and darkness in a color, and because pigments can be more easily mixed to obtain value changes than chroma changes, we will begin by manipulating the value of a hue.

Contrasting values in a design establish distinctive shapes. Gradual value changes, however, are used to express illusions of curved planes and edges of shapes that dissolve in rippling rhythms.

Value changes can be effected by mixing the color with white and/or black pigments in varying proportions. Value can either be manipulated to maintain maximum chroma or to suppress chroma to a minimum. The two methods might also be combined for a fuller monochromatic expression.

The Manipulation of Value

In order to manipulate its value and maintain maximum chroma, a hue must be of considerable brilliance. White is added to obtain steps of lighter values and black to obtain steps of darker values, but white and black are never blended together. The addition of white creates clear *tints*, and black clear *shades*, without any content of grayness or muddiness.

Using the gray scale in figure 84 on page 30 as a guide, we can create nine value steps for a hue. The results resemble those forming the different steps at the right end of each horizontal row in figure 90 on the previous page. Table A shows a rough breakdown of the components of each step; W stands for white, K for black, and H for the hue.

The manipulation of value with minimum chroma makes the hue barely identifiable. To obtain the steps, white and black are mixed as different grays, and small amount of the hue (10 percent or less) is added to each of them. The results resemble those steps forming the left vertical row in figure 90. A rough breakdown of the components of the nine steps can be seen on Table B.

Table A

9	W	80%	K	0%	H	20%
8	W	60%	K	0%	H	40%
7	W	40%	K	0%	H	60%
6	W	20%	K	0%	H	80%
5	W	0%	K	0%	H	100%
4	W	0%	K	20%	H	80%
3	W	0%	K	40%	H	60%
2	W	0%	K	60%	H	40%
1	W	0%	K	80%	H	20%

Table B

9	W	85%	K	5%	H	10%
8	W	75%	K	15%	H	10%
7	W	65%	K	25%	H	10%
6	W	55%	K	35%	H	10%
5	W	45%	K	45%	H	10%
4	W	35%	K	55%	H	10%
3	W	25%	K	65%	H	10%
2	W	15%	K	75%	H	10%
1	W	5%	K	85%	H	10%

Value Gradations with Maximum Chroma

Chroma - strength or weakness
Intensity
Saturation

Colors seem to dissolve when they change gradually over a surface. The strongest color can extend into steps of lighter or darker colors; light steps can follow dark steps, or dark might follow light, to introduce contrast.

Numbers corresponding to the gray scale in figure 84 can be used to plan color distributions. If gradations are arranged as 1, 2, 3, 4, and 5, the value steps proceed from dark to light. If after 8 comes a color corresponding to 2, there will be considerable value contrast. The strongest color may not always be at step 5, as a light hue would have more dark than light steps, and dark hue more light than dark steps. Also bear in mind that the strongest color sometimes makes as great an impact as the lightest or darkest steps in a design (figs. 91, 92).

91

92

Value Gradations with Minimum Chroma

Value gradations with minimum chroma can be used for a subtler effect. The gradual spreading of values creates a pearllike glow, and small areas of light tend to shine amid large dark areas.

Again, the number system can be used to plan color distributions. The steps might proceed smoothly from numbers 1 through 9 without the emergence of a color with full chroma. The lightest and darkest steps tend to be most prominent, and should therefore be positioned for impact (figs. 93, 94).

93

94

CHROMA

Value is key to understanding chroma, as the *value equivalent* of a hue must be determined before chroma can be effectively manipulated.

First, we should have some notion of how a specific hue with the strongest possible chroma can be compared with a particular step of gray along the gray scale. This may not be accurate, as colors of the same hue that are manufactured differently might not be equal in value. The table below, which includes names of colors commonly used, can serve as a guide. Comparing the color in question with a step of gray suggested by the table, and with slightly lighter or darker steps, can help to locate the value equivalent of the color.

Another effective way to establish the value equivalent of a color is to place a sample of that color next to each step of the gray scale. Steps that are obviously too dark or too light can be quickly eliminated. The value equivalent of the color is the step that appears no lighter or darker than the sample.

9	Extremely light gray	Lemon yellow
8	Light gray	Yellow
7	Very light gray	Orange-yellow; Golden yellow
6	Light middle gray	Orange; Yellow-green; Magenta-red
5	Middle gray	Red; Orange-red; Green; Cyan-blue
4	Dark middle gray	Green-blue; Cobalt blue; Turquoise
3	Dark gray	Purple; Ultramarine blue; Violet
2	Very dark gray	Purple-blue; Prussian blue; Indigo
1	Extremely dark gray	None

The Manipulation of Chroma

Differences in value make it difficult to detect differences in chroma. If we concentrate on the manipulation of chroma, the value of a hue must be kept relatively constant. This can be done by limiting all changes in chroma to one value step.

The establishment of a value equivalent is affected by the source of illumination. Incandescent light makes blues darker and yellows lighter. Fluorescent light has an effect on color different from that of sunlight. I prefer initially to compare a color to the steps of the gray scale in broad daylight and to check it again in a dim corner, because we are better able to discriminate between values with a low level of light.

Once the equivalent value is deter-mined, white and black pigments should be mixed to obtain the gray in that value step (pigments usually become lighter when they dry). Gray should then be mixed with the color in the appropriate proportions.

The amount of gray mixed with a color and its possible effects are described in the table below; H stands for hue, N stands for gray. The six steps shown in the table can be increased; however, the number of steps in chroma gradations are usually far fewer than those in value gradations. Once the steps exceed six, the difference between one step and the next is often too close to be recognizable. Certain hues are more suited for a wider range of chroma manipulation than others.

	Hue	(Neutral) Gray
Strong chroma	H 100%	N 0%
Considerable chroma	H 80%	N 20%
Moderate chroma	H 60%	N 40%
Weak chroma	H 40%	N 60%
Faint chroma	H 20%	N 80%
Absence of chroma	H 0%	N 100%

Chroma Gradations with No Shift in Value

Chroma Gradations with Two Hues

Figure 95 shows chroma gradations of a hue with no change in its value. Ideally, all the steps should have the same level of gray in a black-and-white photograph taken of the image.

When mixing a strong color and a gray of equal value, a small amount of the gray can quickly reduce the chroma of the color. This might also lower the value, in which case a small amount of white must be added to the mixture.

It is possible to develop a design with a single hue of constant value and variations in chroma, but shapes may not emerge with sufficient clarity. In most cases, contrasting strong chroma and faint chroma, or absence of chroma, is more effective than creating fine gradations in chroma. A background of a darkened value or black is sometimes used to define shapes. If values, in addition to chroma, are varied, the result could be a full expression of the monochrome.

Until now, I have discussed designs that are limited to one hue. Chroma variations or gradations are much more effective and interesting when two hues are used. The two hues do not have to be related in any particular way, but some contrast between them naturally exists. When the two colors are restricted to one value step, shapes can still be easily distinguished and an interesting color scheme results.

Two hues of the same value step are each mixed with a gray of equal value to obtain a full range of chroma gradations. If two hues have different values, these can be value adjusted by lightening the darker hue with white, or by darkening the lighter hue with black.

95

41

42

The hue that has not been mixed with gray has stronger chroma and will have more chroma gradations. The value-adjusted hue has weaker chroma and fewer chroma gradations.

It is also possible to adjust the value of both hues, mixing one with black and the other with white. The design that results will not feature strong chroma in any of its chroma gradations.

Figures 96 and 97 consist of two hues with the same value and gradations of chroma.

96

97

HUE

The term *hue* is often confused with *color,* but there is a distinction: variations of a single hue produce different colors. For instance, red hue can be light red, dark red, dull or brilliant red, which are color variations within the same hue.

Nature does not provide us with the pigments to describe every hue in the spectrum; pigments that are now available are the products of human efforts throughout many centuries. We therefore have to choose pigments that closely match the standard hues.

It is common knowledge today that red, yellow, and blue can be intermixed to obtain almost any hue. Mixtures, however, weaken chroma, because of inaccurate hue expression, or the physical properties of the pigments, which come from plants, mineral, animal remains, or chemical compounds.

Regardless of these limitations, red, yellow, and blue are the three *primary hues,* and orange (a mixture of yellow and red), green (a mixture of yellow and blue), and purple (a mixture of blue and red) are the *secondary hues.* These constitute the six basic hues, which can be arranged in a circle (fig. 98).

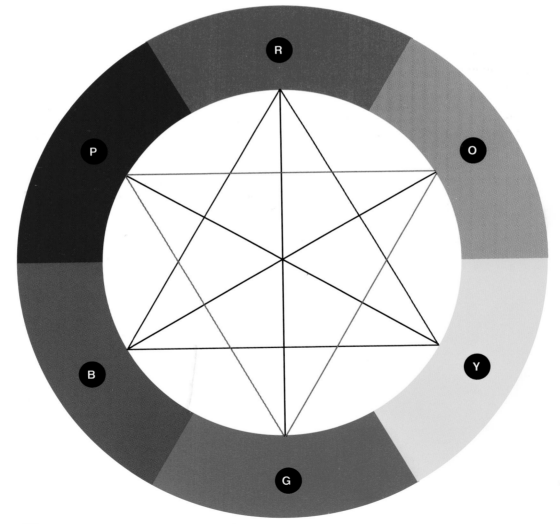

Hue Gradations with Maintenance of Chroma

To effect gradations in hue, we should choose a hue (either one of the six basic hues or their intermediates) as a starting point and another as a terminating point on the color circle. In order to maintain strong chroma throughout the transitions, the two hues are not mixed directly, but each is mixed with an adjacent hue gradually approaching the other on the color circle.

It is simplest to begin with a primary and move to another primary hue. This can be done with the two primaries alone, or with all available pigments that represent the intermediate hues. For instance, we can proceed from cadmium red to cadmium orange with cadmium yellow deep and then cadmium yellow pale. If only red and yellow pigments are used, the mixtures will weaken chroma slightly.

It is more difficult to start with a secondary hue and arrive at another secondary hue. To proceed from purple to orange via red, for instance, it is necessary to use two red pigments: a cool red, such as magenta or rose, is mixed with purple; and a warmer red, such as

flame red or vermillion, is mixed with orange. Mixing the cooler with the warmer reds produces an intermediate color. Similarly, when moving from orange to green via yellow, warm yellow, such as cadmium yellow pale, and a cool yellow, such as lemon yellow, may be necessary. A cool blue, such as cerulean blue, and a warmer blue, such as ultramarine blue, should be considered when moving from green to purple via blue.

Many pigments are needed to effect hue gradations and maintain chroma (see Part III for a recommended list of pigments). It is most important to acquire pigments with the strongest possible chroma, and if the pigment is to represent primary blue, it is necessary to identify its bias towards any adjacent secondary hue. It is best to compare several pigments of the same hue and experiment with mixtures that produce different results.

Figures 99 and 100 show hue gradations covering one-third to one-half of the color circle. Full chroma is exhibited at every transitional step.

Hue Gradations with Chroma Changes

99

Knowing the positions of hues on the color circle and mixing these appropriately with all intermediate steps result in hue gradations with full chroma. Chroma might also be intentionally weakened (for chroma contrast) by mixing any two secondary hues, or by mixing a primary hue with the secondary hue opposite it on the color circle: the two hues neutralize each other and become almost gray (fig. 101).

Another way to weaken chroma is to mix a primary hue with one adjacent (secondary) hue. For instance, a purple-biased blue mixed with green produces a much duller blue-green than would result from mixing a green-biased blue with green.

100

101

THE COLOR SOLID

The three aspects of color—value, chroma, and hue—might be described as the dimensions of color and represented by a color solid. Different color systems use different solids to describe the relationships between colors; the color circle, used here, is most easily transformed into a sphere.

The sphere is composed of segments that represent specific hues in the spectrum. Six segments represent the six basic hues- red, orange, yellow, green, blue, and purple. If the sphere is horizontally divided, a color circle is revealed. The hue contained in each segment is represented in a variety of values (see fig. 89). The upper part of the sphere is of higher value, approaching white at the top, and the lower part grows darker, becoming almost black at the bottom.

The inward-facing straight edge of the segment shows the hue in value gradations of minimum chroma. The outward-facing, curved side of the segment shows the hue in value gradations of maximum chroma. The strongest chroma occurs where bulging is most prominent. Amid the segments is a columnar section that represents the gray scale, with white gradually descending to black (fig. 102).

102

48

The sphere can be thought of as a globe. At the north pole is white and at the south pole black. Between the two poles, eight parallel latitude lines can be drawn, creating nine value zones, with the middle value zone covering the equator. Longitudinal lines divide the globe into six hue zones. Not all the hues in full chroma appear along the equator—the intrinsic value of a hue determines whether it appears in full chroma at the upper or lower portion of its zone. For instance, the strongest chroma of yellow, because it is of light value, occupies a position in the upper portion of the yellow zone. The strongest chroma of blue, because it is of relatively dark value, occupies a position in the so-called southern hemisphere. Figure 103 shows the two sides of this color globe; the location of the strongest chroma of each hue is indicated with black dots.

The sphere bulges wherever the strongest chroma occurs in each hue zone. The globe is therefore distorted in the appropriate places.

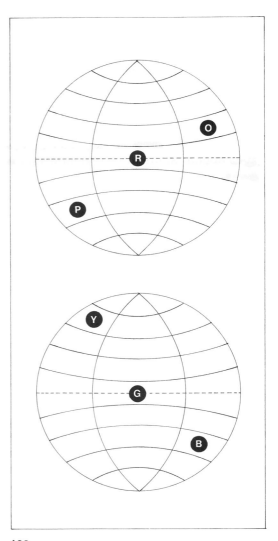

103

Gray Scale
Zones

If the value zones in the globe (see fig. 103) are numbered, just as the steps of the gray scale were numbered in figure 84, we can compare different hues of the same value.

Figures 104-8 show how the six basic hues appear at the more common value zones and illustrate the way different hues can be value adjusted. In value zone 8, yellow is of strong chroma, but blue and purple are of faint chroma (fig. 104). At zone 7, orange-yellow is strong (fig. 105). At zone 6, orange and yellow-green are beginning to appear strong (fig. 106). At zone 5, red and green are at full chroma strength (fig. 107). At zone 4, blue-green, blue, and purple display considerable brilliance (fig. 108).

104

8

105

7

49

106

6

107

5

108

4

COMPLEMENTARY HUES

Hues directly opposite each other on the color circle are called *complementary* hues. The six-hue color circle in figure 98 contains three pairs of complementary hues:

Red (R) and Green (G)
Yellow (Y) and Purple (P)
Blue (B) and Orange (O)

When a hue and its complement are mixed, they neutralize each other, resulting in a muddy gray or brownish color. Mixing the three primary hues also produces a neutral color. These phenomena are described in the simple formulas below, where N stands for the neutral color:

$O = R + Y$
$G = Y + B$
$P = B + R$
$N = R + Y + B$
$R + G = R + Y + B = N$
$Y + P = Y + B + R = N$
$B + O = B + R + Y = N$

The six-hue color circle can be expanded to form a twelve-hue color circle (fig. 109); three pairs of complementary colors have thus been added:

Red-orange and Green-blue
Orange-yellow and Blue-purple
Yellow-green and Purple-red

There is some contrast between any two hues, but complementary hues exhibit the strongest hue contrast, which can be even further enhanced if they are of the same value (figs. 104-8).

Near-complementary hues—two hues that are not directly opposite each other on the color circle, such as red and blue-green, red-orange and green—can be used in place of strict complementary hues to obtain similar effects. In any pair of complementary hues, each hue can split into two or more hues (R can become purple-red and red-orange) or develop separate ranges of value and chroma variations.

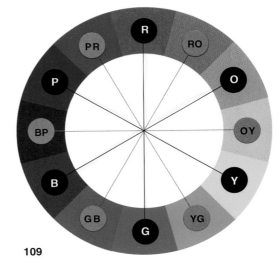

109

COLOR HARMONY

Because tastes change from generation to generation and according to an individual's age, sex, race, education, cultural background, and so on, it is difficult to establish specific rules for creating effective color combinations.

For our purposes, color harmony is best defined as successful color combinations, whether these please the eye by using analogous colors, or excite the eye with contrasts. *Analogy* and *contrast* are thus the two approaches to achieving color harmony. To evaluate these in a design, we must individually consider the value, chroma, and hue of colors.

Hue Harmony

The color circle in figure 92 can be used as the basis for creating hue harmony. The simplest color scheme that can be created using analogy is monochromatic, restricted to one hue. Alternatively, analogous hues can be taken from a portion of the color circle, say, the colors contained within 60 to 90 degrees, and can be randomly juxtaposed or used in gradation within a design.

Analogous hues also result from a common hue bias—a tiny quantity of a particular hue is mixed into each color, sometimes changing its hue, value, and/or chroma in the process. For instance, orange-yellow can be mixed with all colors, creating an overall orange-yellow cast—a tropical color scheme.

Hues contrast significantly when they are separated by 90 degrees or more on the color circle. The wider the distance between the hues on the circle, the greater the hue contrast.

Both analogy and contrast are present in a color scheme if hue gradations cover a large portion of the color circle.

Value Harmony

Chroma Harmony

The gray scale in figure 84 can be used as the basis for creating value harmony. A design with analogous values restricts hue and chroma gradations to just one, or closely adjacent, value steps (see figs. 104–108).

Designs with value gradations can have colors juxtaposed from value steps 2, 4, 6, and 8, or steps 2, 5, and 8 for some value contrast. A design that emphasizes value contrast might have very dark accents in a high-key design, or very light accents in a low-key design.

The concepts of analogy and contrast also apply to chroma harmony. Colors that have the same degree of chroma strength have analogous chroma. Hue gradations with maintenance of chroma therefore result in analogous chroma. Colors in full chroma throughout a design emphasize hue contrast, and weak chroma throughout neutralizes hues and diminishes hue contrast.

Chroma contrast is best effected by restricting colors to one value step, allowing each color to display either strong or weak chroma. Hue gradations with chroma changes result in chroma contrast, as some colors have weakened chroma after they are mixed.

Value, chroma, and hue must all be considered, even when only one of these is manipulated to establish color harmony.

afterimage of a color is its complimentary color on the color wheel

SIMULTANEOUS CONTRAST

The Change of Hue in Simultaneous Contrast

When combining colors, we must pay attention to the effects of simultaneous contrast, which can alter the way colors are perceived. Simultaneous contrast refers to the apparent changes in hue, value, and/or chroma that are created by adjacent colors. Visual stimulation causes the eye to generate an afterimage that is in the hue complementary to the original image. This most often occurs when one color surrounds another (the surrounded color is altered by the surrounding color).

Page 50 shows a total of six complementary pairs: red and green; yellow and purple; blue and orange; red-orange and green-blue; yellow-green and purple-red; blue-purple and orange-yellow. For the purpose of understanding simultaneous contrast, white and black should be regarded as an additional complementary pair.

We can experiment with simultaneous contrast by gathering a wide range of color specimens—colored paper or painted chips—that show a variety of hues with variations in value and chroma. If we punch a hole in each colored chip and look at the same color chip through holes of other color chips, we can see how the value, chroma, or hue of the color changes as a result of simultaneous contrast.

A surrounded color exhibits a change in hue, when it is optically blended with the afterimage of the surrounding color, which is of a different hue. For instance, if orange is surrounded by green, the afterimage of green (that is, its complement, red) tints the orange and makes it appear much redder. If the same orange is surrounded by purple, the afterimage of purple (that is, its complement, yellow) tints the orange and makes it appear much more yellowish. It is important to understand the principles that govern simultaneous contrast, so its effects can be predicted (fig. 110).

We can see the afterimage of a color by staring at a small color sample laid on white paper. If, after thirty seconds or more, our eyes shift from the color sample to the white background, we see an illusion of the shape of the color sample in its complementary hue.

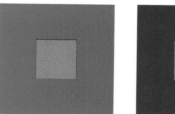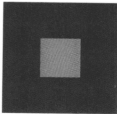

110

Change of Value in Simultaneous Contrast

Change of Chroma in Simultaneous Contrast

A change of value occurs when a sur-rounded color is much lighter or darker than the surrounding color. If the sur-rounding color is light, the surrounded color appears darker; if the surrounding color is dark, the surrounded color appears lighter (fig. 111).

In simultaneous contrast, a change of chroma can be detected if the brilliance of the color seems enhanced, or if the color seems dulled. We can again use the color circle in figure 92 to predict the results.

When a color is surrounded by another that is in its complementary hue, this color is strengthened in chro-ma, because the afterimage of the sur-rounding color is of the same hue as the surrounded color. The surrounded color thus becomes more radiant, tak-ing on an almost fluorescent glow. For maximum effect there should be little value contrast; in other words, one color should be value adjusted to the other (fig. 112).

When two colors being related are within 90 degrees of each other on the color circle, simultaneous contrast can weaken the chroma. For example, orange surrounded by orange-yellow will be affected by the complementary hue of orange-yellow, which is purple-blue. The orange would turn slightly grayish, as the purple-blue cast has a neutralizing effect (fig. 113).

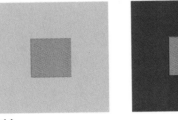

111

112

113

RE-EXAMINING THE COLOR CIRCLE

Names and terms relating to colors are part of our cultural tradition.
Conditioned by the culture in which we are raised, we form fixed notions of how red, orange, yellow, green, blue, and purple should appear, and our color judgment is often affected by our personality, educational background and experiences.

Furthermore, most color systems developed in the early part of the 20th century are based on a set of primary pigment colors—red, yellow, blue—that are rather different from those science has brought to light. The new set of primary pigment colors—magenta, yellow and cyan—are used today for printing, and are generally referred to as process colors. They are transparent inks that can be intermixed in varying proportions, or laid down as separate, solid or tinted layers on white paper to obtain practically any color.

Magenta (M) is a lightened, purple-biased red. Cyan (C) is a pale, greenish blue. The process color yellow (Y) is a bit cooler than what most consider a typical yellow. When intermixed or superimposed, magenta and yellow produce an orange-biased red, yellow and cyan a vivid green, and cyan and magenta a purple-biased blue. These six hues constitute what can be called a *scientific color circle* (fig. 114). With the traditional color circle nested inside the new color circle, relationship of the two circles and corresponding hues is now clearly seen (fig. 115).

While the process colors are excellent for commercial printing, they are fugitive dyes, unsuitable for any type of art work that requires some degree of permanency. As long as we continue to use pigments for color expression, the traditional color circle cannot be superseded. In Part III, we shall look into using paints in tubes or jars, or felt-tip markers, for our design experiments, and we shall stay with the traditional color circle for the time being.

55

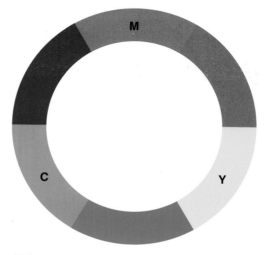

114

56

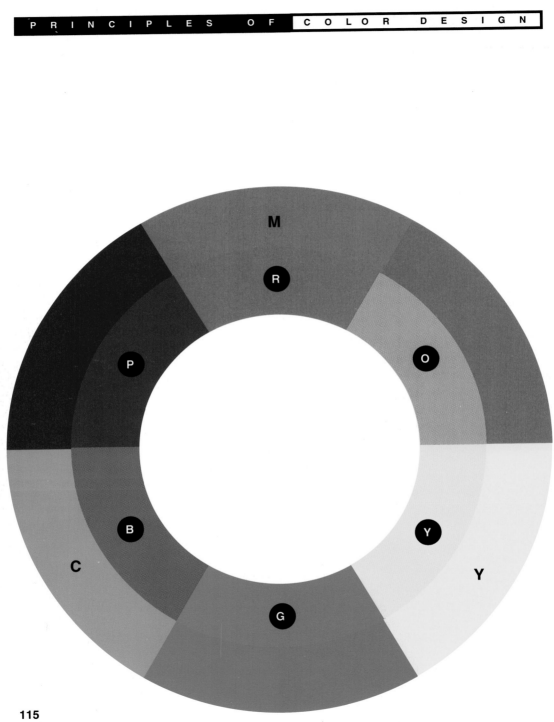

115

PART III : COLOR DESIGN

INTRODUCTION

Tools and Materials

The information gathered in this Part has been taken from different periods of my teaching career. This is reflected in the illustrations, which were created by students in my color design course. These illustrations include abstract designs with points, lines, and planes; geometrical designs with rigid structures; and organic designs based on natural forms. This variety, I believe, offers the reader an opportunity to consider the alternatives and to compare different approaches.

By presenting formal and informal compositions and exploring analogy and contrast in hue, value, and chroma, design and color concepts are thus brought together in a variety of ways. Each illustration represents an attempt to create an effective color scheme, which is the principal aim of this text.

Few tools are required to create color designs. In addition to the basics like pencils, erasers, rulers, and set squares, there are brushes, ruling pens, and bow compasses.

Red sable watercolor brushes with round points are recommended for applying paint to small areas. Wash brushes with flat points (made of soft animal hair) are good for applying paint to large areas. For rectilinear shapes, a ruling pen could be used with more liquefied colors to establish edges before brushes are used to fill in the color. A bow compass can similarly be used for the edges of circular shapes.

White bond paper is generally adequate for sketching, or for initial color visualizations with felt-tip markers. An illustration board of medium grain with a white surface is ideal at later stages of the design process.

The pigments to be used are poster colors that typically come in glass or plastic jars. Designers' colors or gouache colors, which come in tubes, can also be used. The colors must be of a good grade, brilliant enough to express hues of strong chroma, and able to be smoothly applied.

List of Essential Colors

A large assortment of poster colors, designers' colors or gouache colors is certainly desirable, but a small assortment of no more than ten should be adequate as a start. Here is a list of the essential colors (the same colors produced by different manufacturers might bear different names):

R	Red (purple-biased)	Rose, or Magenta
	Red (orange-biased)	Cadmium Red, or Flame Red
O	Orange	Cadmium Orange
Y	Yellow	Cadmium Yellow
G	Green	Cyprus Green, or Brilliant Green
B	Blue (green-biased)	Cerulean Blue
	Blue (purple-biased)	Ultramarine Pale
P	Purple	Purple
W	White	Titanium White
K	Black	Lamp Black, or Ivory Black

Theoretically, we can have just five basic colors, a red, a yellow, a blue, a white, and a black, to mix all the colors we need. Mixing pigments, however, normally reduces chroma or saturation. Furthermore, we must have two reds, one for mixing with orange and another for mixing with purple, and two blues, one for mixing with green and another for mixing with purple.

To reduce the list of essential colors above, we can first take away Purple, for Ultramarine Blue can mix with Rose or Magenta to obtain a purple hue adequately. We can further take away green, relying on Cerulean Blue to mix with Cadmium Yellow to obtain a green hue.

To expand the list, we may look into acquiring Lemon Yellow, which is a green-biased yellow to obtain with the range of yellow-green hues with stronger chroma. We can also get Cadmium Yellow-Orange or Cadmium Yellow Deep for obtaining different orange hues of maximum brilliance.

Many people like to include such colors as brown and yellow ochre. Brown is a combination of orange and black; introducing a bit of purple to yellow produces yellow ochre. These are therefore not essential.

DESIGNS WITH VALUE GRADATIONS

The neutral colors are not necessary for color design exercises, as the manipulation of values with minimum chroma in a design create the same effects as designing with neutral colors.

The faint tint of color in designs with minimum chroma can lend a sense of warmth or coolness to a composition (fig.121). The presence of such a tint of a hue is more noticeable when there are other hues to provide comparison. For instance, figure 116 has a yellowish cast, whereas figure 121 appears brownish, because an orange hue is present. Both designs show value gradations with minimum chroma.

Value gradations maintaining maximum chroma emphasize the hue. When value steps in a design cover a wide range, the value step with the hue at its strongest chroma is most prominent (figs. 122, 123). This is less apparent in figure 120, because the light back-ground tends to darken the hue as a result of simultaneous contrast. Figure 118 features the hue purple-red (which is already a middle value) as the lightest value step. This shortens the value range, reduces value contrast, and enhances chroma contrast, establishing a low-key effect with hue shining in the dark.

Value gradations are effective for creating spatial illusions. Low values against a very dark background fade into the distance, but high values seem to move forward (figs. 116–119, 121, and 122). Against a very light background, dark values seem to move forward, and light values fade into the background (fig. 120).

Figure 123 shows a background of middle value, making both light and dark values stand out. The spatial effects are ambiguous, which is the aim in this design.

Points as Lines in Value Gradations

Points as Planes in Value Gradations

Value gradations can be effected with a sequence of points arranged in lines. The size of points, either round or oval, has to be uniform within one design.

A single round point has no direction, but in a sequence, points become lines that must have an inclination. Overlapping points enhance a sense of depth, particularly in figure 121, where the rows of points seem to laterally penetrate the space behind.

When points are arranged in adjacent lines, they form planes. Points are the textural components of planes (see figs. 122, 123).

Figure 122 features a ribbon-like plane that curves in space; its light values create a metallic glow.

The value gradations of the oval points arranged as square planes in figure 123 suggest diagonals, which do not actually exist in the design.

Designs with Value Gradations

116

117

118

119

63

64

120

121

122

123

DESIGNS WITH CHROMA
GRADATIONS

Differences in chroma among colors of the same hue are best expressed with minimum variations in value. There are fewer gradations of chroma than of value in color, and the clarity of shapes should be maintained when manipulating chroma. Therefore designs that stress the effects of chroma should not be overly complicated, and chroma gradations should have apparent steps and simple rhythms. A dark background is effective, because the colors are heightened by contrast, appearing more luminous.

The illustration included herein may not show all colors with uniform values, because colors are slightly distorted when reproduced. Figures 127 and 130, however, maintain values that are closely related more successfully than the others.

Figures 126 and 129 use a lighter value for the chroma gradations. The strongest chroma step is therefore weaker than that of the other examples, producing a soft image.

Figure 128 contains a dark background as well as several dark planes of slightly lighter value than the background. Values vary here more than in the other designs.

Two hues instead of one were used to create the design in figure 131. Because one hue is darker than the other, the design shows considerable value as well as hue contrast in addition in gradations of chroma.

65

Lines as Bands in Chroma Gradations

Shapes as Patterns in Chroma Gradations

Sequential lines can form ribbon like bands that bend, fold, twist, or knot (see figs. 124, 126, 127, and 129). Figure 125 shows only straight bands. Fig. 128 shows a band in disarray at one end and intercepted with solid planes.

Chroma gradations cannot be easily manipulated to create illusions of depth as can value gradations. We might expect the strongest chroma to advance and the weakest chroma to recede in space, but if the chroma gradations vary slightly in value, the darker values recede and the lighter values advance on a dark background regardless of the chroma strength. Bands of color, however, can suggest a tubular shape, especially in figure 127, where the strongest chroma is at the center of the band (see also figs. 125, 129).

Figures 130 and 131 demonstrate how shapes can be used to create patterns in chroma gradations. The shapes are actually birds that appear as planes in figure 130 and as line and plane combinations in figure 131.

The shapes in figure 130 are first rotated and then translated. The rotation consists of six birds, which together become a super-unit form that is then translated in a staggered grid. There is little depth illusion except that the strong orange advances slightly.

Figure 131 also features a super-unit form in translation—four birds arranged in two groups. Each group has two overlapping birds and is rotated 180 degrees from the other group within the super-unit form. The pattern emphasizes a diagonal arrangement.

Designs with Chroma Gradations

124

125

126

127

68

128

129

130

131

DESIGNS WITH HUE GRADATIONS

In value gradations, only one hue is introduced with chroma either in maximum or minimum expression. In chroma gradations, one or two hues can be used with slight changes in value. In hue gradations, a wide range of hues allows for a fuller expression of color. When effecting hue gradations, we can either maintain consistent value or chroma, but not both. Hues at full chroma strength differ considerably in value (see discussion of the color solid in Part III). When all the hues are confined to one value step, value-adjusted hues normally show a weakening of chroma.

To establish a range of hue gradations, it is necessary to determine the following:

a. the first hue in the range
b. the last hue in the range
c. the number of steps in the gradation
d. how hue transition is effected

Fixing the first and last hues in the range determines whether the range will be narrow or wide. A narrow range comprises analogous hues, as in figure 133, which contains hues that are within 60 degrees of each other on the color circle. When a design contains a wide range of hues, these can encompass half of the color circle (fig. 135), or even the whole color circle in exceptional cases.

The number of steps in the gradation depends on the design. More steps of gradation effect slow changes in hue and produce a smooth design (fig. 136). Fewer steps of gradation effect rapid changes, which quicken the rhythm and increase the contrast in the final image (figs. 137, 138).

The way chroma strength is maintained or changed affects the transition between hues. Figures 132, 133, 135, and 136 are examples of hue gradations in full chroma throughout the transitions; figures 134, 137, 138, and 139 show some weakening of chroma among the greens, due to mixtures of yellow and purple-biased blue hues. Hues that are a great distance from each other on the color circle can be mixed directly to produce a range of hue gradations with a marked reduction of chroma strength.

69

Lines in Hue Gradations

Lines and Planes in Hue Gradations

Figures 132 through 134 are composed of sequences of lines that form bands. Refer to figures 125 through 129 to see how hue gradations are different in effect from chroma gradations. In hue gradations, yellow, the hue with the lightest value, is the most visible, particularly on dark backgrounds. Value still plays an important role in the creation of spatial illusions.

Figures 135 through 137 feature lines floating in space. In figure 135, two sets of parallel lines are at right angles to each other, with one vertical line bisecting the angle. Analogous colors appear on the left side of the design, but proceed toward complementary contrast, clearly represented by the green vertical line on the red background.

The lines in figure 136 gradually change direction, creating a loop in space. The lines in figure 137 change direction as if being pulled by gravity.

The design area was divided into flat planes before the lines were positioned in figures 138 and 139. The planes tend to impose a pattern, confining the movements of the lines and restricting the play of illusory space by limiting depth. Both figures also show changes in chroma strength in the hue gradations, particularly noticeable in the weaker chroma of the green hues.

Figure 138 features parallel lines in two directions; the yellow lines stand out more than others. Hue gradations are not orderly arranged.

The lines in figure 139 go in all directions. The progress of hue gradations in the planes is the reverse of that in the lines, and hue contrast is the least prominent among the central planes.

Designs with Hue Gradations

132

133

134

135

72

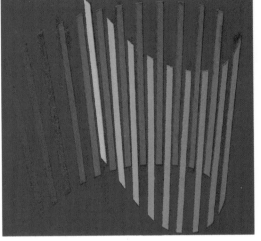

136

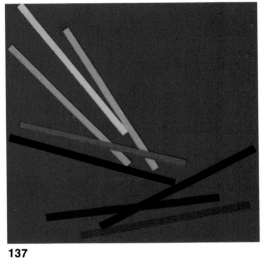

137

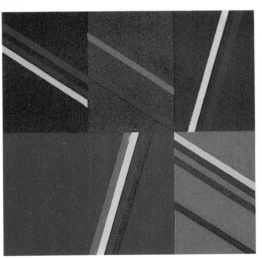

138

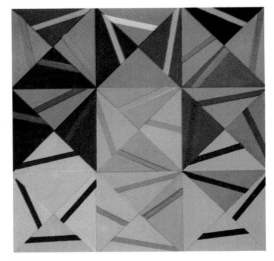

139

DESIGNS WITH HUE MIXTURES

Warm/Cool Sensations Generated by Hues

Any two hues can be mixed to form a range of hue gradations. If they are analogous and are correctly biased, the hue gradations that result maintain considerable chroma strength (fig. 140). If they are not analogous and/or not correctly biased, the result will show weaker chroma in the mixtures (figs. 141, 145, 146). When complementary hues are mixed, chroma weakens to a significant degree (figs. 142, 143, 147).

The presence of weakened chroma in the range of hue gradations enhances chroma contrast, because the two original hues stand out distinctly from their mixtures.

Our knowledge of hue is incomplete without an understanding of warm/cool sensations generated by hues. A *warm* sensation is created with the presence of the hue associated with fire—orange (a mixture of red and yellow). Any hue containing red, yellow, or both expresses warmth. A *cool* sensation is generated by the presence of the hue associated with water or sky—blue. A hue containing blue expresses coolness.

The warmth or coolness of a hue, however, is relative; a hue may seem warm when compared with a cooler hue and cool when compared with a warmer hue. The greater the amount of red or yellow in a hue, the warmer it appears. Likewise, the more blue present in a hue, the cooler it seems. Green, for instance, has an equal amount of yellow and blue. It seems warm when compared with yellow-green, which contains more blue, but appears cool when compared with blue-green, which contains more yellow. The hues between red and yellow are all warm; it is difficult to compare warm and cool effects among these, though hues closer to the standard orange are generally considered warmer.

Warm/ cool sensations also affect spatial illusion in a design. Because warm hues seem to advance whereas cool hues seem to recede, the warmth or

Overlapping Planes in Hue Gradations

coolness of elements in a design can effectively express space. The way a hue relates to its background is also important. It tends to stand out if contrast with the background is great, and to fade when it blends into the background.

Hues can be mixed to establish a smooth transition between warm and cool sensations. At a certain stage in the mixture, the color may exhibit no inclination toward warmth or coolness. Simultaneous contrast resulting in a change of chroma significantly affects the warm/cool sensations. A strong warm color can make a weaker color of the same hue look cool, and conversely, the strong cool color can make a weaker color of the same hue look warm.

A sequence of overlapping planes expresses an illusion of depth that is further enhanced with hue gradations. This illusion works especially well if the colors at one end of the range blend into the background (fig. 140).

Most of the examples here display ambiguous spatial effects, particularly figures 143 and 146. Figures 140 and 141 feature flat curvilinear planes; others are rectilinear shapes that are rotated and/or translated into stacked, bent, folded, or torn configurations.

In figures 146 and 147, the hues that are mixed are also given value variations or gradations.

Designs with Hue Mixtures

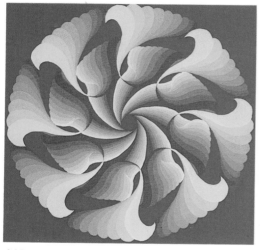

140

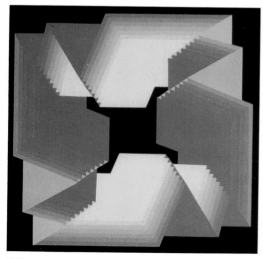

142

141

143

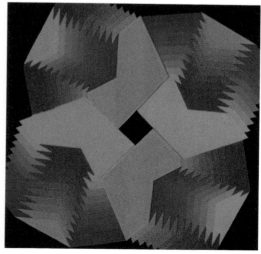

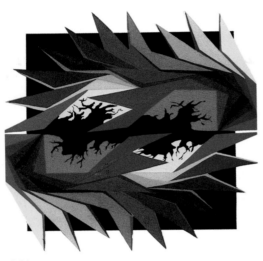

144

145

146

147

DESIGNS WITH COMPLEMENTARY HUES

Complementary hues lie on opposite sides of the color circle. They produce the greatest hue contrast, especially when value differences are minimal. Eye-catching designs are therefore generally created using complementary hues.

Hues that are not exactly 180 degrees apart on the color circle are considered *near-complementary* hues and have effects similar to complementary hues.

Split-Complementary Hues

Split-complementary hues establish a multicolored scheme with analogous and contrasting color relationships. Split-complementary hues are obtained by replacing one of the complementary hues with the hues adjacent to it on the color circle. Red and green thus become red and yellow-green, green-blue; or, purple-red, red-orange, and green.

It is also possible to split hues without replacing any of the complements. For instance, the complements of red and green can become split complements by including yellow-green and blue-green, or purple-red and red-orange.

Splitting one of the complementary hues in a pair produces three or four hues, and splitting both produces even more. A multicolored scheme with analogous and contrasting hues is thus created.

Near-complementary hues are split in a similar way.

Illusory Volumes Created with Complementary Hues

Figures 148 through 153 all feature illusions of volume using complementary hues. Blue, red-orange, and orange-yellow form a split-complementary color scheme in figures 152 and 153. With the blue hue slightly heightened in value, the three hues are seen roughly in the value steps of 4, 6, and 8, adding visual clarification to the three-dimensional illusions.

Figures 148 through 151 explore ambiguous representations of volume and space with the direct mixing of complementary hues. Figure 148 also incorporates value variations in the process of hue intermixing.

The compositions in figures 148, 149, 150, and 152 display a wide expanse of background, which tends to emphasize depth.

Creating Patterns with Complementary Hues

Figures 154 and 155 have overall patterns created with invisible lines that form a grid made up of numerous spatial cells (subdivisions of space). Shapes are generally confined to the spatial cells, but sometimes introduce variations and accentuations that keep the designs from becoming monotonous patterns.

Split-complementary hues are used in both illustrations. A scintillating effect results from hues of closely related value, which is particularly obvious in the reds and greens of figure 155.

Designs with Complementary Hues

148

149

150

151

80

152

153

154

155

Complementary Hues with Hue Gradations

Complementary Hues with Value Gradations

Either or both of the complementary hues in a color scheme can, instead of splitting into its adjacent hues, mix with these to produce a range of color gradations. Dissolving effects are achieved if the gradations are smooth (figs. 156, 157).

Figure 158 demonstrates the same effect, although the hue gradations actually extend to cover half the colors in the color circle. The large planes, however, are of complementary hues and therefore dominate the color scheme. The edges of the planes are softened with sequential lines forming hue gradations.

Figures 159 through 161 explore complementary hues with value gradations. Figure 161 also shows a bit of hue inter-mixing. The value effects in these illustrations are more apparent than the contrast between the complementary hues, which do not always exhibit strong chroma when they are adjacent.

The informal composition in figure 160 is divided into three parts by invisible lines, which interrupt only slightly the continuity of shapes.

Figure 161 is a formal composition with bilateral symmetry; dissecting invisible straight lines form four rectangular panels in the lower-middle portion of the design. The image is reflected along a central axis, but one hue sometimes changes to the other on the opposite side of the axis.

The design area in figure 159 is formally divided into regular spatial cells, and there are concentric dilations. The image is based on a kind of flower, which is not presented as a regular shape with repetitive, symmetrical elements. The regular and irregular aspects, however, make the design interesting. The complementary hues in their full chroma are more closely related here than they are in figures 160 and 161. Because red and green are at the same value step, there is strong

Complementary Hues with Chroma Gradations

contrast between hues and the design scintillates.

When the design area is divided, it becomes spatially transformed; it seems as if something transparent, or with refracting or reflecting properties, were superimposed on the design. Each part of the design might be spatially autonomous, with shapes and background only indirectly related to adjacent parts.

Complementary hues with chroma gradations are illustrated in figures 162 and 163. Both are pattern designs featuring pairs of birds formed by 180-degree rotations, and then regularly translated. A black background clarifies the shapes.

Although the design concept in these illustrations is similar to that of figures 130 and 131, complementary hues provide strong accentuation when colors have full chroma.

More Designs with Complementary Hues

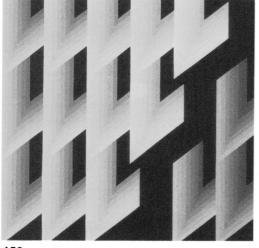

156

157

158

159

84

160

161

162

163

DESIGNS WITH UNRELATED HUES

We can systematically choose hues for a particular color scheme that exhibit certain relationships—either analogous or complementary hues, for instance. Three hues 120 degrees apart on the color circle are called *triads* and these are often combined in a color scheme. It is also possible that any number of hues can be chosen from the color circle at random to create an effective color scheme, provided that value and chroma are suitably manipulated.

Unusual color schemes can result from these unrelated hues, which are sometimes the product of an intuitive choice from among available colors. The dissimilarities of hues in varying degrees of hue contrast are thus emphasized.

Several unrelated hues of considerable chroma strength lead to multicolored effects (figs. 164–167). Unity can be achieved by using either warm or cool colors and by providing stronger hue contrast at the center of interest. Values can be manipulated by mixing the pigments, but if these are not mixed, the value of each color must be considered separately. The color scheme might also be expanded to include black and white.

Tinting all of its colors with a common hue also unifies a color scheme (figs. 168–170). This softens hue contrasts and establishes some analogy between dissimilar hues (see Part II, Hue Harmony). It is almost as if the colors are seen through a transparent colored filter, or under a colored light.

85

Flat Planes of Unrelated Hues

Unrelated Hues with a Dominant Tint

A Chinese character or components of the character are arranged on a dissected background in figures 164 through 167. Character shapes are sometimes dissected as well, creating more areas for color application.

The character strokes are joined as flat planes that do not overlap. Space in these designs is either occupied or unoccupied, and dissection introduces some ambiguity. The illusion of depth is not effected by the shapes, but more by the advance of warm colors and the recession of cool colors, particularly in figure 165, where yellow and pink become the center of interest, standing out from the cool colors that make up most of the design.

Figure 167 features a series of white diagonal lines that divide the design into numerous strips, separating all of the colors. The background is black. The overall design is muted compared to the vivacity of figure 164, the icy effect of figure 165, and the tranquillity of figure 166.

The unrelated hues in figure 168 all have a greenish-brown tint, which creates a sense of warmth, though blue is present. The tint generally weakens the chroma of all the hues, keeping hue contrast to a minimum. The overall pattern has slightly overlapping shapes, which do not lend a great sense of depth to the design.

Figures 169 and 170 have a dominant orange-yellow tint, which unifies unrelated hues. The gradation of hue is used to soften the rotated, overlapping shapes. The effect of value gradations is even more significant than the effect of hue gradations, as the yellow-orange hue, lightest in value and strongest in chroma, makes distinct highlights.

164

Designs with Unrelated Hues

165

166

167

168

169

170

DEVELOPING A COLOR SCHEME

Innumerable options are available for developing a color scheme. A color circle is not limited to six basic hues, although color thinking is based on the simple six-hue device. Deviations from these basic hues can be regarded as hue adjustments, which moves a hue to one of its adjacent hues on the color circle. There are also value and chroma adjustments. The various adjustments offer thousands of colors that can be chosen and combined in a particular design.

A color scheme refers to the colors that are selected for a design; a group of colors that works well in one design may not be effective in another. This is because the positions of colors, the size of color areas, and the effects of simultaneous contrast must all be considered. Quick color sketches with a large assortment of felt-tip markers can be used to visualize these effects before a final decision is reached.

When developing a color scheme, we should begin by choosing a dominant hue and consider variations in value and chroma as well as additional hues. If a color scheme is restricted to only one hue, it is monochromatic, allowing value and chroma changes but no changes in hue. In most cases, a color scheme includes more than just one hue. The chosen hue can be accompanied by its adjacent hues to form a range of analogous colors. The wider the range, the more varied is the color sensation created by the design.

A dominant hue might be accompanied by a subordinate hue to provide necessary contrasts and occasional accents. The two hues may have a complementary or near-complementary relationship and can be extended to become split-complementaries. Hue adjustments sometimes obscure analogous or complementary relationships, which lead to a color scheme of unrelated hues.

When the hues have been determined, value and chroma adjustments and variations should be considered. We might, alternatively, decide whether the composition will be of high key, intermediate key, low key, uniform value, maximum chroma, or minimum chroma, before choosing the hues for the color scheme.

A Color Scheme with Analogous Hues

A Color Scheme with Complementary Hues

Analogous hues generally express a soft harmony, stressing similarities rather than differences between the hues. Hue contrast still exists, however, when the beginning and end hues in a range of analogous hues are compared.

Hue contrast is evident in figure 171: purple-red is next to purple-blue and other blues. The use of both warm and cool colors enhances the effect of the contrast between hues. Hue contrast is also present to a lesser extent in figures 173, 175, and 177. It is least apparent in figure 174, which exudes a sense of warmth; contrast exists only in the values of hues.

A neutral gray is part of the color scheme in figures 172 and 176. Simultaneous contrast alters the way gray is perceived, which makes the color scheme appear more varied; complementary contrast is faintly expressed, with gray acting as the complementary hue.

Figures 178 through 181 have color schemes with split-complementary hues. Figure 182 has intermixed complementary hues, and figures 188 through 190 feature complementary hues with value adjustments.

None of the designs here exhibits very strong hue contrast. Strong value contrast is apparent in figures 178 and 181; scintillation occurs in the lightened blue adjacent to the darkened orange shapes. In figures 179, 180, and 182, most of the hues are of weaker chroma strength, which reduces the harshness of complementary contrast.

Examples of Color Schemes

171

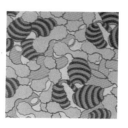

172

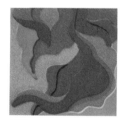

173

174

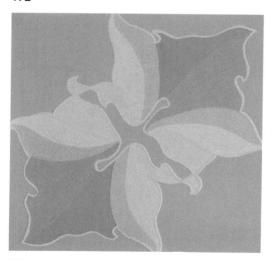

175

176

177

178

179

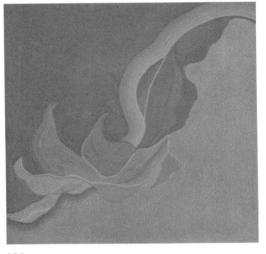

180

181

182

183

184

185

186

187

A Color Scheme with Unrelated Hues

The Control of Value and Chroma in a Color Scheme

Deviations from analogous or complementary relationships establish color schemes of unrelated hues (these can include triads or near-triads). A color scheme of unrelated hues is multicolored if most of the hues have strong chroma (see figs. 164–166). Figures 183 through 187 feature subdued colors with considerable variations in value.

It may not be easy to identify a color scheme of unrelated colors. For instance, figure 183 resembles a color scheme with analogous hues; figure 184 could be mistaken for a color scheme of split-complementary hues. This does not really matter. Most important is that we arrive at an effective and interesting color scheme.

After hue adjustments are made to a color scheme, the value and chroma of colors are manipulated. A hue is either heightened or lowered in value, strengthened or weakened in chroma. The value and chroma of a hue are related, so a change in one can easily affect the other. Values might be closely related to enhance chroma contrast. It is also possible to weaken chroma without changing the values of hues if these are mixed with grays of the same value.

Figure 188 is in the high key. Orange here is of strong chroma, appearing slightly darker than the light blues, which create luminous shadows around the shapes. Figure 190 is also in the high key; all colors here are within one value step, with yellow in full radiance among the blue and orange hues of much weaker chroma.

Figure 189 is in the intermediate key. Purple is heightened in value, but its chroma is intense enough so that it contrasts with the yellow-green hue. Purple and yellow-green are mixed, resulting in a slight lowering of value to provide subtle value and chroma contrasts.

In Search of a Color Scheme

Figures 191 and 194 are in the low key. Figure 191, especially, has uniform value throughout the design, with dark orange shapes emerging from the blue ground and other adjacent dark hues. Figures 192 and 193 are also in the low key, but slightly lighter values are used as accents.

These illustrations are not restricted to particular hue relationships. Figures 188 through 191 feature complementary hues; the rest feature unrelated hues. We should refer to the illustrations presented earlier in this section to see the effects of changes in value and chroma. For instance, figures 176, 177, 179, and 183 all contain significant adjustments in value.

It is useful to experiment with a wide variety of color schemes for a single composition. Figure 195 explores thirty-six variations, yet the composition remains almost unchanged.

The range includes monochromes, analogous hues, complementary hues, unrelated hues, and colors of closely related values. These five different approaches can be seen as the basic directions we might head in our search for an effective color scheme.

More Examples of Color Schemes

188

189

190

191

192

193

194

96

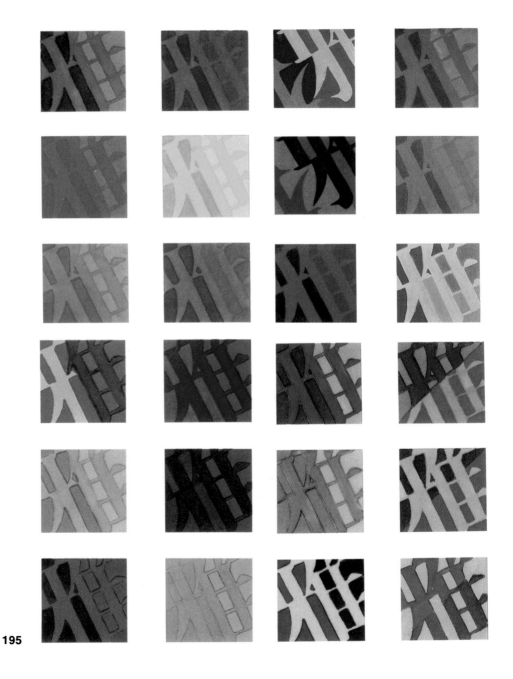

195

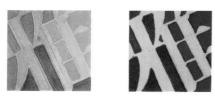

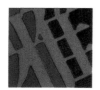

PART IV : DIGITAL COLORS

PART IV : DIGITAL COLORS

INTRODUCTION

In the form of pigments, colors seem to have a real, physical presence. For design visualization, we have to sketch the composition carefully, and fill individual areas with premixed pigments. To develop a color scheme, we might have spread pigments on paper as color specimens, and arrange them side by side to examine the effects. Any adjustment to the colors in a design usually requires remixing the pigments and redoing the design. The process can be quite time-consuming.

The rapid development of the computer in the last few decades has revolutionized our way of creating design. The computer utilizes a monitor, similar to a television screen, to display colors and images. Colors are the effects of digital signals that cause electronic energy to emit from a cathode-ray tube (CRT) to hit on a glass screen coated with fluorescent phosphors, which glow as colors.

Digital signals can be made with operations transmitted through either a *mouse* or a keyboard. Both are linked to the central processing unit (CPU) of the computer. The mouse is a small, simple instrument shaped like a rounded bar of soap, with a button outside and a ball inside, and can be dragged on a pad to move a cursor on screen, with or without depressing the button. The key-board is for typing, but can also issue commands for specific tasks.

Many graphics software programs have been developed. They enable computer users to paint and draw with colors, to create images, to manipulate photographs, and to originate types. Colors and images can be corrected or modified if necessary, all with considerable speed and ease. What is on screen can be subsequently printed on paper with a printer connected to the computer, or saved on a disk for printing at any output center.

Today the computer is already a common piece of equipment in design studios, offices, and homes. Although it cannot totally replace the use of pigments for design work, more and more designers tend to choose the computer for initial visualization and final execution of their ideas. We do not have to know exactly what goes on inside the computer, but we must be able to use it in order to serve our needs.

Since colors on the computer are accomplished with color lights, this Part will first examine the principles of color lights. Then it will introduce the computer's basic principles as related to the creation and display of digital colors, the computer's capabilities to paint and draw, and its relationship with the printing process.

101

COLOR LIGHTS

Light is a kind of electromagnetic energy in the form of waves of varying lengths measured in nanometers (abbreviated as nm), which are one thousand-millionth (10^{-9}) of a meter. The unaided normal human eye can only perceive light as color within a certain range of wavelengths, from 400 nm to 700 nm, which forms the visual spectrum (fig. 196). Above 700 nm, there are the infrared rays, and below 400 nm, the ultraviolet rays, X rays and gamma rays. All such rays are invisible to us.

The retina of the human eye consists of two kinds of cells, known as rods and cones, each with different functions. The rods perceive the value and strength of the light. The cones perceive light as colors, and fall into three types, each type being particularly capable of sensing only one wavelength sector in the visual spectrum. Together they determine that three specific wavelength sectors, interpreted as colors which are generally referred to as *red*, *green* and *blue* in science and technology, are of paramount importance in our color vision (fig. 197).

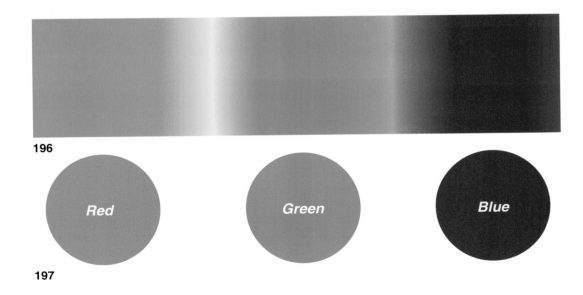

196

197

Red *Green* *Blue*

The Primary Color Lights

In fact, we can achieve any colors with just the three color lights identified as *red*, *green* and *blue*. They are the primary color lights.

As hues, however, the *red* appears much orange-biased and differs considerably from our common notion of what red should be (fig.198), green seems slightly yellowish (fig. 199), and the *blue* is more like blue-purple (fig. 200).

These primary color lights have been called by other names, but now the names *red*, *green,* and *blue* have been more commonly adopted, especially in the computer industry, and must be incorporated into our color vocabulary. To avoid confusion with the hues in the traditional color circle, I always show them in the italicized form.

198

199

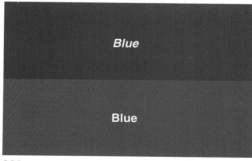

200

The Additive Process of Color Mixing

Mixing primary color lights to obtain other colors is an additive process. We can get yellow (Y) by mixing *red (R)* and *green (G)*, cyan (C) by mixing *green (G)* and *blue (B)*, and magenta (M) by mixing *blue (B)* and *red (R)*. Yellow, cyan, and magenta are the secondary color lights.

Figure 201 shows the three primary color lights in partial overlapping to produce the three secondary color lights, and white (W) when they all overlap one another.

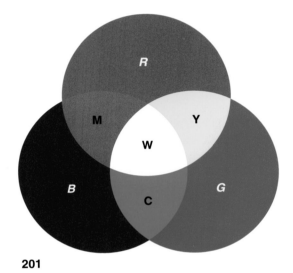

201

The Subtractive Process of Color Mixing

In the color printing process, the white of the paper is regarded as reflected white light. As printing inks are transparent, each ink layer acts a color filter which can block certain wavelength sector of the light.

With magenta ink, *green* light is blocked. With yellow ink, *blue* light is blocked. With cyan ink, *red* light is blocked.

If magenta and yellow inks overlap, both *green* and *blue* lights are blocked, and *red* results. If yellow and cyan inks overlap, both *blue* and *red* lights are blocked, and *green* results. If cyan and magenta inks overlap, both *red* and *green* lights are blocked, and *blue* results. When the three inks overlap one another, all light is blocked and black results.

Figure 202 shows the inks magenta (M), yellow (Y), and cyan (C) in partial overlapping to produce *red (R)*, *green (G)*, and *blue (B)*, and black (K) when they all overlap. This demonstrates the subtractive process.

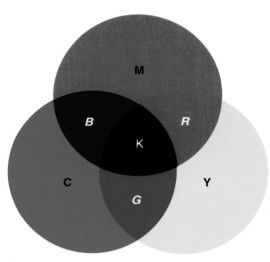

202

In printing, we can say the three process inks magenta (M), yellow (Y) and cyan (C) are the primary colors and *red, green,* and *blue* are the secondary colors. A fourth process ink, black (K), is often added for darkening colors.

These four process inks, generally referred as CMYK (fig. 203) can be printed as solid or tinted layers with which all other colors can be achieved. A tinted layer (fig. 204) is normally printed as a pattern of round dots (fig. 205). Color photographs can be reproduced convincingly by printing with the four process inks in halftone patterns which overlap at different angles (fig. 206).

204

205

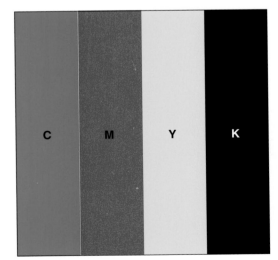

203

206

DISPLAY OF COLORS AND IMAGES

The computer utilizes bundled *red,*
green, and *blue* beams of electrons in
varying velocities to create the different
color lights on the monitor screen.

Screen display is composed of tiny,
square units called *pixels,* a term
derived from combination of two words,
picture and *element.* Images are formed
with contiguous pixels in similar and dif-
ferent colors that map the screen in a
grid of horizontal rows and vertical
columns (fig. 207). An average monitor
has a resolution of 72 pixels to an inch,
or 72 ppi. Each pixel can be clearly
seen when an image is considerably
enlarged.

207

Pixel Depth

Each pixel carries specific color information provided by its bit resolution, or pixel depth, which determines the number of colors available to the pixel as it forms part of an image.

Pixels of *one-bit depth* have 2^1 or 2 values, and can only show black or white (fig. 208). Pixels of *8-bit depth* have 2^8 or 256 gray levels (fig. 209), or 256 colors (fig. 210), which could be adequate for most design jobs. A discriminating colorist may prefer to work with pixels of *24-bit depth* to achieve 2^{24} or 16,777,216 possible colors.

209

208

210

Types of Images

Image resolutions depend on how they were first created or acquired. There are two main types of images: *raster* images and *vector* images. Both types can be in black and white, grayscale, or full color.

Raster images may either be photographs acquired with a scanner (fig. 211), or those created in a paint or image-editing program (fig. 212). They are also referred as *bitmap* images as they are composed of a definite number of pixels that determine their resolution. They could appear noticeably jagged when enlarged (figs. 213, 214).

Vector images are those created with a draw program (fig. 215). They are resolution-independent *objects*, described by a series of points that are mathematically defined, and can be indefinitely enlarged without losing their crispness (fig. 216).

211

212

109

110

213

214

215

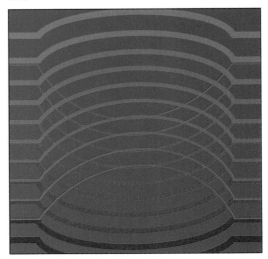

216

PAINTING ON THE COMPUTER

All graphics programs provide a *tool box* on screen, containing an array of tools. Clicking with the mouse selects one tool, and the mouse cursor might change in shape to represent the tool. With a paint program installed in the computer, we can paint by dragging the mouse cursor on screen to simulate effects of painting on blank paper.

Overlapping one painted shape upon another is usually an irreversible act, for the pixels of a newly painted shape instantly replace those underneath on the same layer.

The most common tools for painting are the *pencil* and the *brush*. The pencil is generally for dry, fine lines (fig. 217). The brush is for both thick and thin lines and can achieve transparent, wet and dissolving effects (figs. 218, 219). Some paint programs might also offer other tools to simulate effects of charcoal, pastel, crayon, watercolor, or felt-tip markers on smooth or grainy surfaces.

217

218

219

Spraying, Filling, and Erasing

There is the *spray tool* for spreading fine mists or coarse dots of color to create blurred images (fig. 220). It is particularly suitable for retouching photographs to alter or add color transitions and shapes (fig. 221).

A *fill tool* can color an area that is enclosed with a painted line or plane (fig. 222), change the color of an area painted in one contiguous color (fig. 223), or cover the unpainted background with a color (fig. 224).

An *eraser tool* can be used to make corrections by removing part of a painted shape, or by introducing negative lines or shapes on it to reveal the background (figs. 225, 226).

221

112

220

222

223

225

224

226

Selecting, Lassoing, and Duplicating

To select any painted shape in a contiguous color, we can use the *magic wand tool* to click on it, which will be instantly surrounded with dashed white outlines. We can then drag it slightly off-position, move it to another location, or simply delete it, leaving a gap or hole that reveals the background (fig. 227).

We can select more than one shape by clicking on each shape while holding down the shift key on the keyboard. The selected areas may be flipped, rotated, reflected, scaled, or distorted (fig. 228), and some or all of the holes and gaps may be later filled with another color (fig. 229).

Another way of selecting a shape is to enclose it by drawing an outline with the *lasso tool*. We can also use this tool to draw any new shape and move or delete it. If lassoing includes any portion of the background, the lassoed background will also be moved like any opaque shape (fig. 230).

We can duplicate any selected or lassoed shape by dragging it to another location while depressing the option key, leaving the original untouched (fig. 231).

In doing this, we can obtain as many duplicated copies as desirable from the same shape by repeating this process (fig. 232).

227

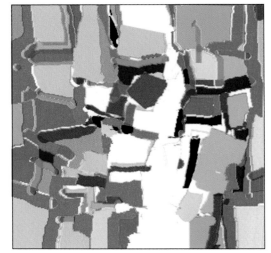

228

114

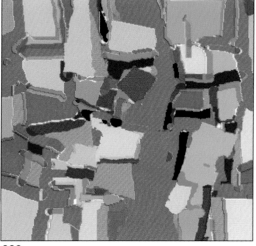

229

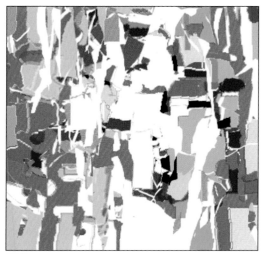

230

231

232

Marqueeing and Masking

There is the *marquee tool* for drawing a square, rectangle, circle, or ellipse that maps over an area. The marqueed area can then be deleted, moved, or duplicated (fig. 233).

Each color area inside a marqueed area may be refilled with a different color by using the fill tool (fig. 234).

We can turn any lassoed or marqueed area into a mask that protects the area inside or outside the mask from the subsequent painting (fig. 235).

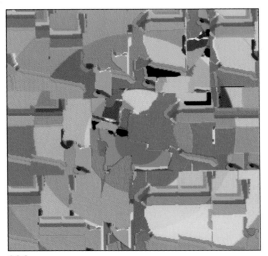

234

233

235

Anti-aliasing and Feathering

Hard edges are aliased, as seen in marks produced with the pencil tool. This means that the shape and the background are harshly divided along the edge (fig. 236). Soft edges are anti-aliased, for the shape and the background are bridged with gradually spreading tiny pixels in fading colors (fig. 237).

Antialiasing is a common feature in paint and image-editing programs. This helps eliminate the austerity of saw-tooth edges made by conspicuous square-shaped pixels.

To attain anti-aliasing, we can use the *blur tool* to soften a hard edge with a dissolving effect (fig. 238), and we can engage the *smudge tool* to blend parts of a hard edge with the surrounding area (fig. 239).

An area selected with the wand, lasso, or marquee tool might be moved, or copied and pasted, with anti-aliased borders (fig. 240). Moreover, we can use a *feathering* option, to get exaggerated anti-aliased effects along the borders of any selected area (fig. 241).

236

237

238

240

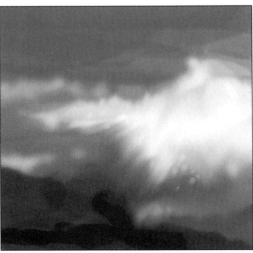

239

241

DRAWING ON THE COMPUTER

A draw program has a different set of tools and enables us to create lines and shapes, as well as typed characters and texts, in any desirable color with superb clarity and crispness. Drawn images are vector-based objects—always scalable, movable, and editable. They can be created in exact measurements, positions, and directions.

The advantages of a draw program over a paint program is in its precision and flexibility, making it particularly suitable to design work that requires searching into various options and previewing them on screen quickly and effectively.

The most basic tools in a draw program are the *line* and *pen tools* with which straight, bent, and curved lines can be created (fig. 242). Lines are *paths* that link up end *points*, or contain intermediate points that can be visible when selected but not printable (fig. 243). They can be *stroked* to show a desirable weight and color (fig. 244).

A line can enclose an area to form a shape which can be filled with color, but one can also use the *shape tools* to originate squares, rectangles, circles, ellipses, triangles, and regular polygons. These shapes can be stroked and filled (fig. 245), stroked without a fill, or filled but not stroked (fig. 246).

242

243

119

120

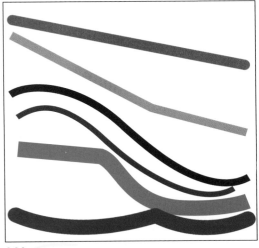

244

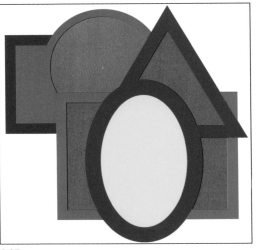

245

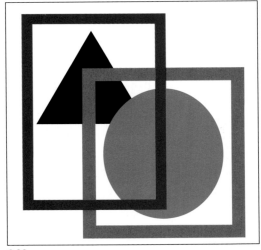

246

Originating Type

Although we can originate type in a paint program, the characters obtained normally have anti-aliased edges and might lack crispness. In a draw program, typed characters and texts are always sharp and clear. The *type tool* enables us to originate type in any font style, size, and color (fig. 247), arranged along straight or curved lines (fig. 248), or in rectangular, circular, or specially shaped blocks (fig. 249). Types can be scaled in various proportions (fig. 250), flipped, rotated, or skewed (fig. 251), and can be converted into outlined shapes, subsequently stroked and filled (fig. 252), or joined with other shapes (fig. 253).

248

121

247

249

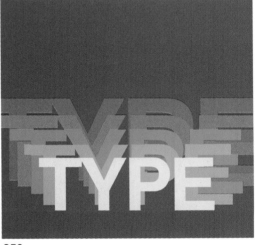

250

251

252

253

Manipulation of Shapes and Elements

Selecting a line or a shape can be easily accomplished with an *arrow tool*. As the points appear, indicating that the shape has been selected, we can move it to any position on screen (figs. 254, 255). We can change its attributes with relevant commands (fig. 256), alter its size and proportion with the *scale tool* (fig. 257), or change its direction with the *rotate tool* (fig. 258). Moreover, we can flip it with the *reflect tool* (fig. 259), slant it with the *skew tool* (fig. 260), or manipulate it successively with different tools.

255

256

254

123

257

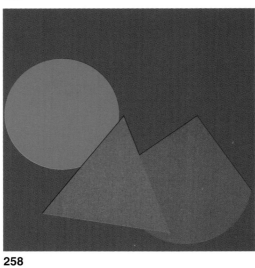

258

259

260

In a group of shapes, we can bring any individual shape to the front or send it back (fig. 261). The group can be collectively scaled, reflected, skewed, or given new attributes (figs. 262, 263).

Moving or removing an existing point, or adding a new point on a shape can alter its configuration (figs. 264, 265). A shape's straight edge can become a convex or concave curve (fig. 266). An outward protrusion can be pushed inward (fig. 267).

262

261

263

264

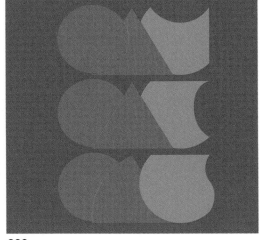

266

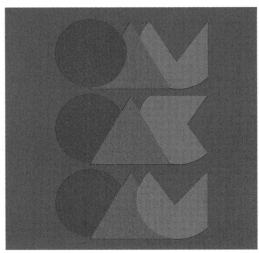

265

267

Duplicating Shapes and Movements

It is easy to drag a copy of a selected shape or a group of shapes from an original, use the *duplicate command* to obtain further moved copies to form a row, and give individual copies new attributes (fig. 268). Subsequently, we can select the row and repeat the process to form a repetitive pattern (fig. 269). We can try out different color combinations with the shapes and the backgrounds (figs. 270–272).

We can also rotate a copy of a shape and use the duplicate command to achieve a design displaying full rotation (figs. 273, 274).

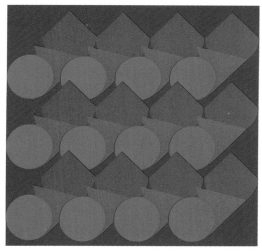

269

127

268

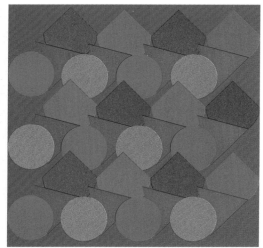

270

271

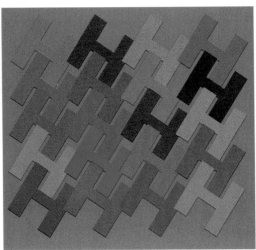

272

273

274

Tiled Patterns

For an overall repetitive pattern to fill
any shape, we can employ a shape or a
group of shapes as a motif (fig. 275) for
a *tiled pattern* to fill any existing or sub-
sequently created shape or shapes
(figs. 276, 277). We can rotate and
scale the tiled pattern, and fill its back-
ground with any color (fig. 278). We can
transform and repeat it with the same or
different background colors (figs. 279,
280), and can superimpose it on anoth-
er shape with a different tiled pattern
(fig. 281).

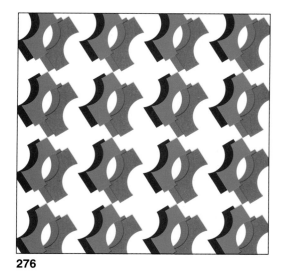

276

275

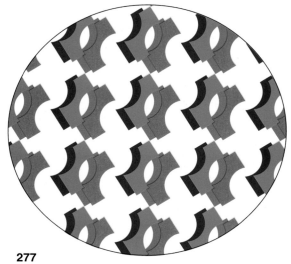

277

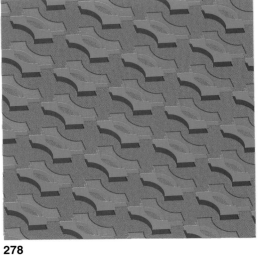

278

280

279

281

Blending Lines, Shapes, and Colors

One wondrous feature of a draw program is its capability to blend lines, shapes and colors. This is accomplished with the blend *command* or the *blend tool*.

We can blend two lines or shapes of the same configuration but of different colors, in any predetermined number of steps (figs. 282, 283). We can also blend two lines or shapes of different configurations as well as attributes, with steps showing all the gradual changes (figs. 284, 285).

We can blend a small shape inside a large shape of similar configurations but of different colors, and achieve a concentric effect, showing gradual changes in size and color (figs. 286, 287).

282

283

284

286

285

287

Creating Gradients with Blends

Blending two lines of different colors in innumerable steps can achieve a gradient effect showing smooth, gradual color change (figs. 288, 289). The last line in the blend can be copied to blend with another line in another color. The process can be further repeated to create complex blending effects (fig. 290).

Blending a tiny or very narrow shape inside a large or wide shape in numerous steps can result in a gradient with radiating effect (figs. 291–294).

289

288

290

291

293

292

294

Gradient Fills

Instead of blending lines or shapes, we can give any enclosed shape a gradient fill. This can either be a graduated fill with straight, parallel, gradual color changes (fig. 295), or a radial fill with circular, concentric color changes (fig. 296) from one color to another. We can change the direction of the graduated fill (fig. 297), and we can relocate the center of the radial fill (fig. 298). Both types can have multicolor gradients.

For complex color effects, we can even blend two shapes with the same type of gradient fills (figs. 299, 300).

295

296

136

297

299

298

300

COLOR PALETTES

Both paint and draw programs provide an assortment of basic colors on a *color palette* in the shape of a box containing tiny squares or bars of the color specimens, generally the neutral colors, the primary and secondary colors, and "none" (fig. 301). To this palette, the designer can easily add or subtract colors, establishing a personal palette to meet specific requirements (fig. 302).

The color palette may also include built-in *color libraries*, such as Pantone®, Trumatch™, and others, each offering hundreds of pre-mixed colors with reference numbers. Printed samples of the colors in the color libraries may be purchased for comparing screen displays with final results on paper.

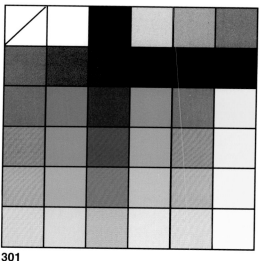

301

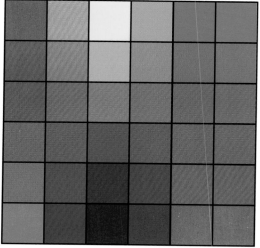

302

Picking or Creating a Color

To pick a color for use, we can click on any color on the color palette, or on one of the color swatches in a color library. A *color picker* in the form of a circular color map with all the colors in the visual spectrum is often available, and from it we might be able to choose a color that can be used directly or with modification (fig. 303). Another kind of color picker carries all the variations of value and chroma within a single hue as that hue is selected (fig. 304).

To create a color, the color palette might provide a color mixer with three separate modes for color mixing: the *RGB mode*, the *CMYK mode* and the *HLS mode*. Each mode provides a set of sliding bars which we can manipulate to obtain a new color or to modify a chosen color. As we move the button on a bar, a numerical value (usually as percentages) is displayed in a box next to it. To effect changes, we can type a new numerical value in the box instead of moving the bar.

138

303

304

The RGB Mode

The RGB mode is directly associated with the way the screen display is composed with the primary color lights *red (R)*, *green (G)* and *blue (B)*. Giving 100 percent to each of the three primary color lights will produce white, giving zero percent to each will produce black, and giving 50 percent value to each will produce a middle gray (fig. 305).

In the middle gray situation, if we change *red* to zero percent, we can achieve a darkened cyan (fig. 306). Similarly, instead of changing *red*, we can change *green* to zero percent to achieve a darkened magenta (fig. 307), or change *blue* to zero percent to achieve a darkened yellow (fig. 308).

If we give one of the primary color lights 100 percent, and another zero percent, then we can give the third in different percentages to produce a range of colors of strong chroma with all the hue variations (figs. 309, 310).

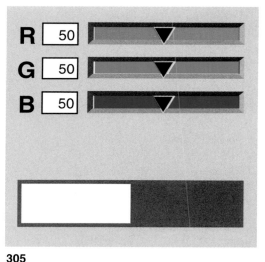

305

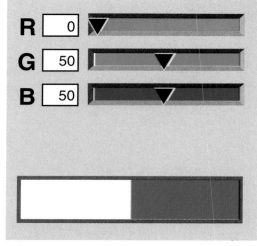

306

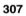

140

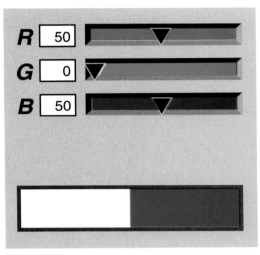

307

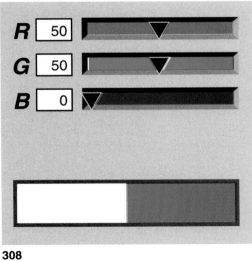

308

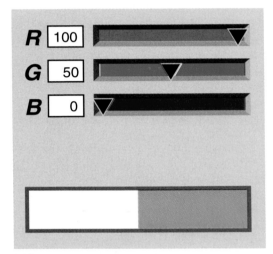

309

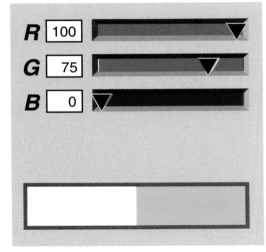

310

The CMYK Mode

Creating colors in the RGB mode engages the additive process of color mixing. Working in the CMYK mode is similar to working with pigments and engages the subtractive process as related to commercial printing.

The four bars in the color mixer represent the four process inks cyan, yellow, magenta, and black. We could slide the buttons on the cyan, magenta, and yellow bars to try out mixing results, and use the black bar for darkening.

When black and one of three other colors remain at zero percent, we can achieve clear tints or fully saturated colors (figs. 311, 312). C, M, and Y in equal percentages, with K remaining at zero percent, result in neutral gray (fig. 313). Neutral gray is also formed when C, M, and Y are in at zero percent, but the K bar alone is moved (fig. 314).

For a muted color, we could start with a gray obtained with equal percentages of C, M, and Y, as in figure 313, and manipulate just one or two of them for subtle coloration (fig. 315).

If we start with a neutral gray obtained with the K bar alone, as in figure 314, and use just one or two of the C, M, and Y bars for coloration, we cannot produce a muted color. Instead, a clear shade results (fig. 316). Grayness in a color requires the co-presence of C, M, and Y in the mixture.

311

312

141

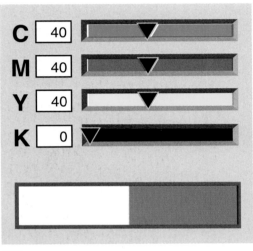

313

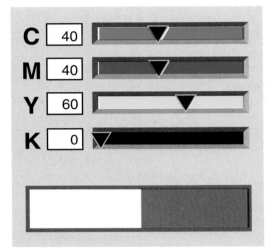

315

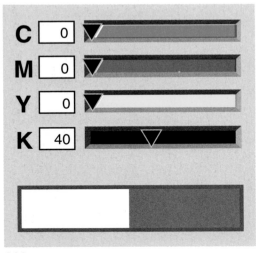

314

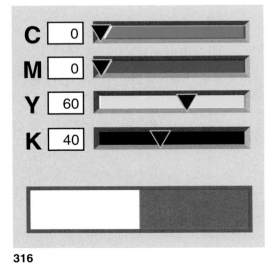

316

The HLS Mode

The HLS (Hue/Lightness/Saturation) mode is also variously called the HSB (Hue/Saturation/Brightness) mode, or the HSV (Hue/Saturation/Value) mode in different graphic programs. This refers to the creation of colors with choice of hue, and subsequent manipulation of value and chroma.

Working in this mode is similar to working with the color picker, where we can click on any part of the circular map to choose a color. Next to this color map is a vertical bar for value adjustments. Three adjacent boxes display numerical values for hue, value, and chroma that may be changed by typing.

The circular color map has red at zero degrees, yellow at 60 degrees, green at 120 degrees, cyan at 180 degrees, blue at 240 degrees, and magenta at 300 degrees, in a counterclockwise arrangement.

The color map is initially displayed at 50 percent brightness, with colors around the circumference at full saturation proceeding towards a middle gray at the center (fig. 317). Increasing the brightness value will lighten the map (fig. 318), and decreasing this value will generally darken it (fig. 319).

After adjusting the vertical bar for brightness, we can pick a color near the center for lower color saturation, or type a value in the saturation box to attain weaker chroma (figs. 320–322).

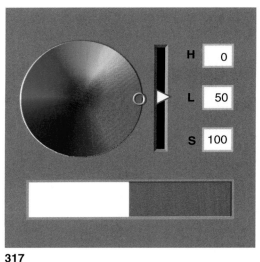

317

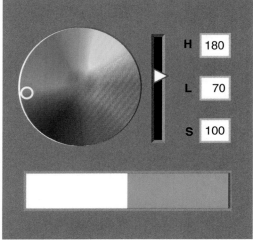

318

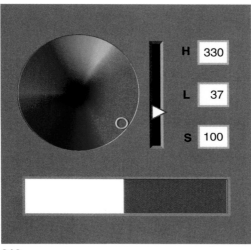

319

H	330
L	37
S	100

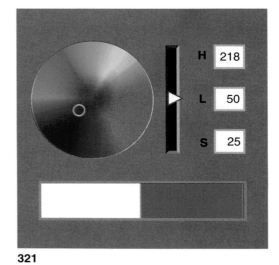

321

H	218
L	50
S	25

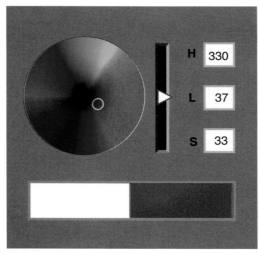

320

H	330
L	37
S	33

322

H	80
L	70
S	25

PRINTING THE COLORS

What appears on the computer monitor is only an illusion of digital light. It can be printed on paper or film, as solid or continuous-tone images in full color, or as black-and-white color separations.

A color image can be printed with desktop printers directly connected to the computer. Outputs can be in an inkjet, thermal wax, dye sublimation, or color laser process, with varying characteristics, qualities, and costs. In all instances, the RGB display becomes superimposed C, M, Y, and K layers.

We must know that colors seen by the human eye in real life have a greater range than colors on the monitor screen, and colors on the monitor screen have a greater range than colors printed on paper. These ranges are referred to as color *gamuts*. Some programs give warning signs when colors created in the RGB mode are beyond the CMYK gamut. Figure 323 shows a comparison of these gamuts, with the background shape representing the visible spectrum, the yellow ring representing the RGB gamut, and the white ring representing the CMYK gamut.

323

Specifying Colors in Eight-digit Codes

In commercial printing, the four process inks C, M, Y and K are either mixed to form *spot colors* for printing in one impression, or printed in solid or tinted layers. A spot color is always crisp and clear, as the premixed color is printed only once in a single operation on the press. A color printed with successive ink layers may contain halftone dots and may show fuzziness due to inaccurate registration.

On the computer, we can obtain any color in terms of CMYK percentages. We can also choose a color from a book of color specimens with specifications of CMYK percentages, and mix that color digitally on the computer.

Thus we can give any color a numerical code in a CMYK-percentage sequence. For instance, cyan may be coded **C**100/**M**0/**Y**0/**K**0, to stand for a mixture containing 100 percent cyan, zero percent magenta, zero percent yellow, and zero percent black. This coding system can be simplified in a neat, eight-digit sequence without the CMYK prefixes, with 99 representing 100 percent and 00 representing zero percent.

In this manner, cyan can be coded 99/00/00/00, magenta 00/99/00/00, yellow 00/00/99/00, and black 00/00/00/99.

Figure 324 shows colors progressing from *red* to cyan and further to *green* bearing the eight-digit codes. This coding system will be the basis for all the color descriptions in Part V.

146

00/99/99/00

25/75/75/00

50/50/50/00

75/25/25/00

99/00/00/00

99/00/25/00

99/00/50/00

99/00/75/00

99/00/99/00

324

PART V : COLOR EXPRESSION

PART V : COLOR EXPRESSION

INTRODUCTION

Any single color or combination of colors might contain a symbolic meaning, convey a message, attract attention, evoke emotions, or display a special mood. A designer must understand what colors can do or express in order to use them effectively in communication, decoration, or for any special purpose.

Social and cultural contexts, human psychology, as well as fashion trends, are the factors that can affect how colors are seen, felt, and interpreted. Not all such factors are objective, for there are individual preferences that usually vary from person to person. The designer has personal preferences too, and creation of color harmony is inevitably based upon one's own judgment and taste.

For any specific color expression, it is important to understand all the requirements for achieving a predetermined goal. A systematic color thinking process could begin with choosing one main color and looking into other colors to work with it. In any color scheme, adjustment to hue, value, and chroma can lead to significant changes in color expression. Alternatively, we start with a small range of colors, and try out different combinations.

On the computer, selecting, creating, and adjusting the colors are more easily done in the CMYK mode if results are to be commercially printed. For precise color specifications, each final color should be described in terms of CMYK percentages.

This Part will introduce some basic color sets, and present a series of color guides based on various color families and ranges. The color guides contain numerous color schemes for reference and adaptation by readers or designers of any discipline. Each color in the color guides bears an eight-digit code to help readers reproduce it accurately on screen.

Monochromatic Color Sets

An idea for color expression could begin with a set of colors related to a predetermined goal. The set of colors should be visualized on screen, so that we can see them and duplicate those we like for experiment with combinations.

For a monochromatic color set, we can easily have one saturated color (H to stand for any hue) to make five blends of five steps each, forming 25 colors, in the following manner:

100%H + 0%K to blend with 10%H + 5%K
100%H + 5%K to blend with 10%H + 25%K
100%H + 10%K to blend with 10%H + 45%K
100%H + 15%K to blend with 10%H + 65%K
100%H + 20%K to blend with 10%H + 85%K

Monochromatic sets of red, orange, yellow, green, blue, and purple, based on our common notions of these colors, are shown in figures 325 to 330.

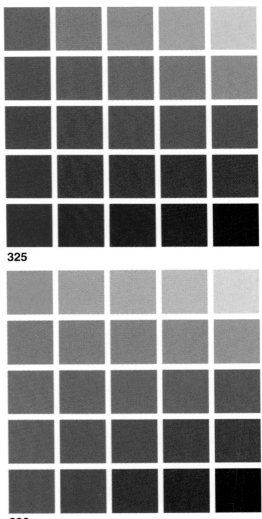

325

326

327

329

328

330

Color Sets with Blending Different Hues

To obtain a set of analogous colors, we can blend two adjacent colors on the color circle, with value and hue changes (figs. 331–335).

For a set of colors encompassing a wider range of hue, value, and chroma differentiations, we can blend two to four colors, in full or partial saturation, randomly chosen from the color circle (figs. 336–349).

If we blend two complementary colors, the two colors will mix into a neutral gray at the middle point of the blend (figs. 350–353).

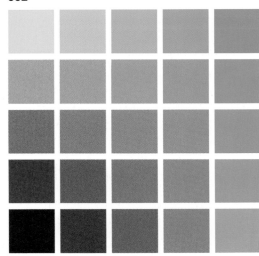

332

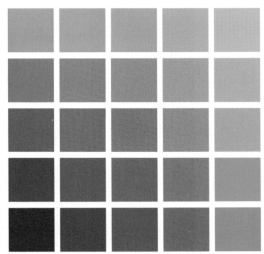

331

333

334

336

335

337

153

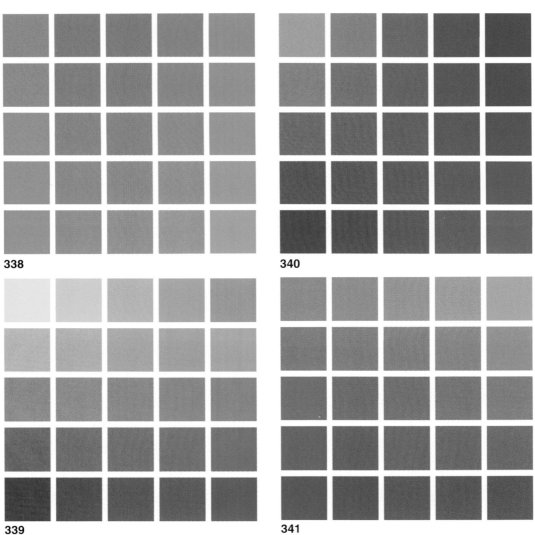

338

340

339

341

342

344

343

345

346

348

347

349

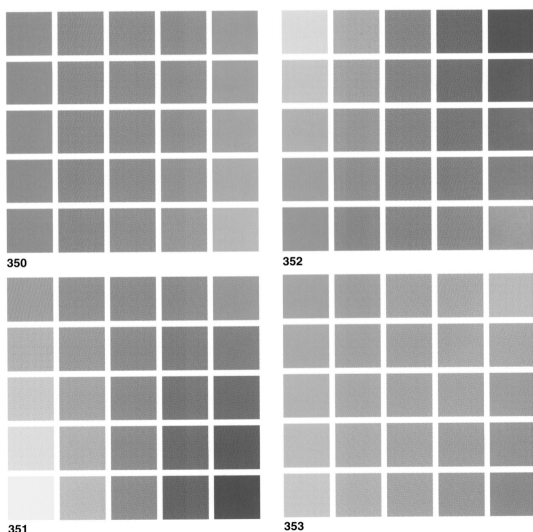

350

351

352

353

COLOR GUIDES

The next pages will contain eleven
series of color guides representing dif-
ferent color expressions. Each series
features a family or range of colors,
including:

The red family (fig. 354)
The orange family (fig. 355)
The yellow family (fig. 356)
The green family (fig. 357)
The blue family (fig. 358)
The purple family (fig. 359)
The high key colors (fig. 360)
The intermediate key colors (fig. 361)
The low key colors (fig. 362)
The earth colors (fig. 363)
The near-neutrals (fig. 364)

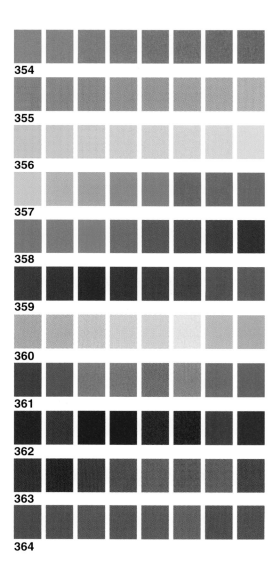

354

355

356

357

358

359

360

361

362

363

364

The Red Family

The red family (fig. 365) ranges from magenta with a small yellow content (00/99/10/00) to a red-orange (00/90/99/00). Our common notion of red is about 10/90/80/00. The presence of 10 percent cyan is for counteracting the effect of yellow, but this somewhat desaturates the color.

Red in full saturation is the color of the rising sun, of burning charcoal, of intensely heated metal, and of blood. Thus it stands for hope, power, hotness, excitability, and danger. It is stimulative, provocative, and even aggressive. It is probably the most eye-catching among all colors of the visual spectrum. Adding white changes red into pink, and adding magenta changes it into rose. Presence of black makes it a burgundy or maroon color. Pink, rose, burgundy, and maroon are all part of the red family, conveying different feelings. Its chroma weakens with presence of cyan in the color mixture.

We can use red to form color combinations with slight variations in hue, value, and chroma (fig. 366), to work with other colors of contrasting hues (fig. 367), or in a color scheme with generally desaturated colors (fig. 368).

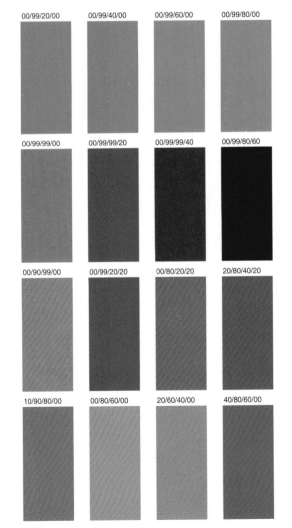

365

159

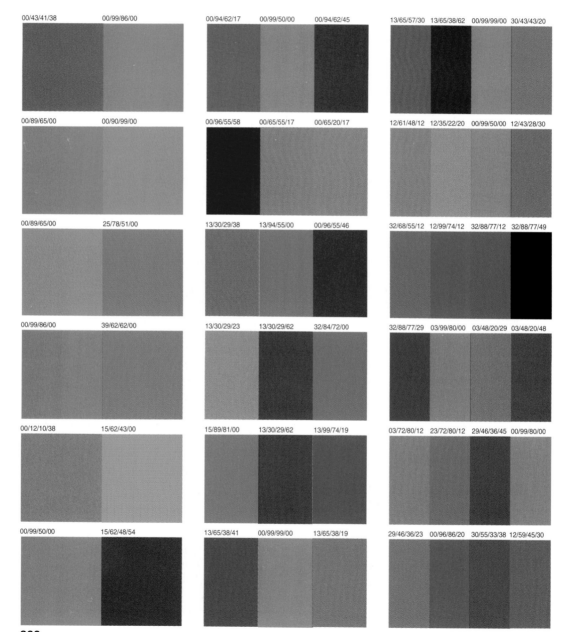

00/43/41/38 00/99/86/00 00/94/62/17 00/99/50/00 00/94/62/45 13/65/57/30 13/65/38/62 00/99/99/00 30/43/43/20

00/89/65/00 00/90/99/00 00/96/55/58 00/65/55/17 00/65/20/17 12/61/48/12 12/35/22/20 00/99/50/00 12/43/28/30

00/89/65/00 25/78/51/00 13/30/29/38 13/94/55/00 00/96/55/46 32/68/55/12 12/99/74/12 32/88/77/12 32/88/77/49

00/99/86/00 39/62/62/00 13/30/29/23 13/30/29/62 32/84/72/00 32/88/77/29 03/99/80/00 03/48/20/29 03/48/20/48

00/12/10/38 15/62/43/00 15/89/81/00 13/30/29/62 13/99/74/19 03/72/80/12 23/72/80/12 29/46/36/45 00/99/80/00

00/99/50/00 15/62/48/54 13/65/38/41 00/99/99/00 13/65/38/19 29/46/36/23 00/96/86/20 30/55/33/38 12/59/45/30

00/00/99/00 00/90/99/00

00/36/99/00 00/90/99/00 12/35/22/20

59/99/00/00 25/99/65/00 00/99/99/00 30/43/43/20

46/72/00/00 00/90/99/00

48/91/00/00 00/99/50/00 19/77/72/03

12/61/48/12 13/99/00/00 00/99/50/00 99/00/00/00

99/45/00/00 10/99/50/00

57/00/99/19 13/94/55/00 00/83/88/00

03/72/80/12 15/81/43/00 00/99/80/00 99/00/48/07

99/00/99/00 00/99/86/00

99/48/00/99 13/30/29/62 00/99/80/00

99/41/00/00 03/99/80/00 03/48/20/29 15/81/43/00

99/00/10/00 00/83/46/00

99/00/38/00 00/99/50/00 15/81/43/00

00/94/55/00 23/72/80/12 00/65/20/17 55/00/99/00

99/84/00/00 00/99/62/29

17/78/46/00 00/99/90/00 84/03/59/00

17/90/54/06 00/99/90/35 30/55/33/38 99/83/00/00

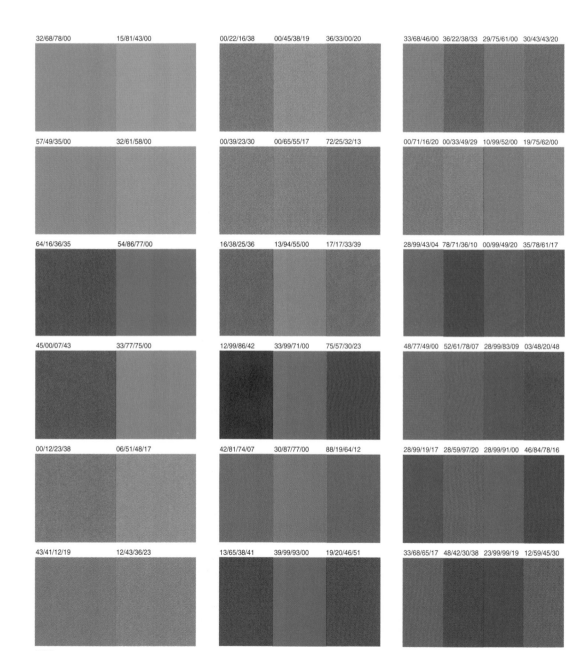

32/68/78/00 15/81/43/00

00/22/16/38 00/45/38/19 36/33/00/20

33/68/46/00 36/22/38/33 29/75/61/00 30/43/43/20

57/49/35/00 32/61/58/00

00/39/23/30 00/65/55/17 72/25/32/13

00/71/16/20 00/33/49/29 10/99/52/00 19/75/62/00

64/16/36/35 54/86/77/00

16/38/25/36 13/94/55/00 17/17/33/39

28/99/43/04 78/71/36/10 00/99/49/20 35/78/61/17

45/00/07/43 33/77/75/00

12/99/86/42 33/99/71/00 75/57/30/23

48/77/49/00 52/61/78/07 28/99/83/09 03/48/20/48

00/12/23/38 06/51/48/17

42/81/74/07 30/87/77/00 88/19/64/12

28/99/19/17 28/59/97/20 28/99/91/00 46/84/78/16

43/41/12/19 12/43/36/23

13/65/38/41 39/99/93/00 19/20/46/51

33/68/65/17 48/42/30/38 23/99/99/19 12/59/45/30

The Orange Family

The orange family (fig. 369) ranges from orange-red (00/80/99/00) to orange-yellow (00/50/99/00). They are colors of the tasty orange fruit, evening glow, and fire at the hearth.

Fully saturated orange colors represent warmth, friendliness, and cheerfulness. Their visibility is high, and like red, they are also used for warning signals to remind people of possible danger. Mixed with black, they change into browns and ochres. Mixed with cyan, they turn more yellowish and their chroma weakens.

Figure 370 shows orange in hue/value/chroma variations forming monochromatic or analogous color schemes.

Figure 371 shows color schemes featuring orange and other colors, displaying hue contrasts.

Figure 372 shows subdued color schemes with orange and other colors in low saturation.

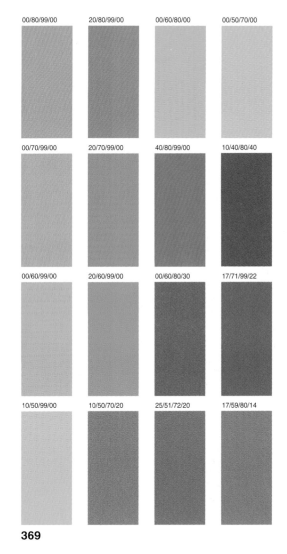

00/80/99/00 20/80/99/00 00/60/80/00 00/50/70/00

00/70/99/00 20/70/99/00 40/80/99/00 10/40/80/40

00/60/99/00 20/60/99/00 00/60/80/30 17/71/99/22

10/50/99/00 10/50/70/20 25/51/72/20 17/59/80/14

369

163

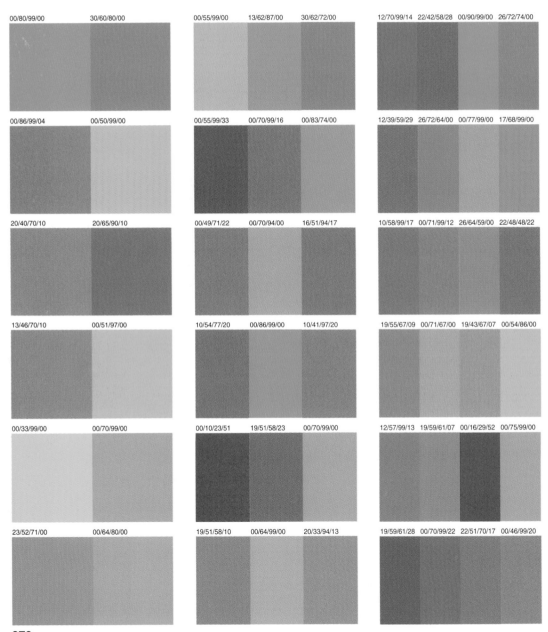

00/80/99/00 30/60/80/00

00/86/99/04 00/50/99/00

20/40/70/10 20/65/90/10

13/46/70/10 00/51/97/00

00/33/99/00 00/70/99/00

23/52/71/00 00/64/80/00

00/55/99/00 13/62/87/00 30/62/72/00

00/55/99/33 00/70/99/16 00/83/74/00

00/49/71/22 00/70/94/00 16/51/94/17

10/54/77/20 00/86/99/00 10/41/97/20

00/10/23/51 19/51/58/23 00/70/99/00

19/51/58/10 00/64/99/00 20/33/94/13

12/70/99/14 22/42/58/28 00/90/99/00 26/72/74/00

12/39/59/29 26/72/64/00 00/77/99/00 17/68/99/00

10/58/99/17 00/71/99/12 26/64/59/00 22/48/48/22

19/55/67/09 00/71/67/00 19/43/67/07 00/54/86/00

12/57/99/13 19/59/61/07 00/16/29/52 00/75/99/00

19/59/61/28 00/70/99/22 22/51/70/17 00/46/99/20

00/99/00/00	17/65/99/00		14/55/90/00	00/74/99/00	99/29/00/00		00/75/43/17	19/99/00/00	00/90/99/00	19/86/71/00
99/57/00/00	00/50/99/00		00/52/86/09	00/70/99/16	99/00/70/00		12/39/59/29	17/68/99/00	00/77/99/00	87/26/00/00
99/99/00/00	00/65/90/10		00/39/72/28	00/70/94/00	99/00/17/00		04/41/90/09	00/75/62/00	00/57/88/09	97/00/48/00
99/00/39/00	00/60/99/00		10/54/77/20	00/50/99/00	74/00/99/00		00/38/99/04	19/58/99/00	00/72/99/00	16/77/00/00
86/00/99/00	00/70/99/00		00/10/23/51	00/64/99/00	14/72/00/07		42/86/00/00	23/72/80/12	03/59/96/04	00/58/51/20
91/20/33/00	00/57/99/00		22/59/99/22	00/64/99/00	00/13/99/00		23/52/77/13	00/86/99/04	00/67/99/00	46/75/99/07

371

165

22/49/26/12 30/60/80/00 35/57/78/00 13/62/87/00 59/17/17/09 13/49/61/12 26/45/77/07 13/49/71/07 00/67/99/00

41/17/41/10 22/46/70/00 19/68/86/09 25/54/67/17 17/57/38/17 12/39/59/29 29/45/78/16 20/55/88/00 17/68/99/00

72/20/70/00 07/45/83/09 43/51/62/00 29/51/62/00 25/25/67/17 10/58/99/17 09/46/68/19 20/72/83/00 58/25/36/19

32/45/23/09 13/55/77/00 10/54/77/20 26/58/71/09 70/51/38/00 00/16/29/30 17/38/67/14 10/42/86/00 46/22/33/10

80/30/29/00 13/71/94/00 00/10/23/51 10/55/99/09 64/10/38/10 17/32/52/23 17/57/64/10 00/16/29/45 61/10/45/20

83/41/35/00 25/64/80/00 28/57/80/14 16/46/67/14 17/64/71/00 13/42/49/33 17/64/68/09 07/38/84/23 49/33/45/20

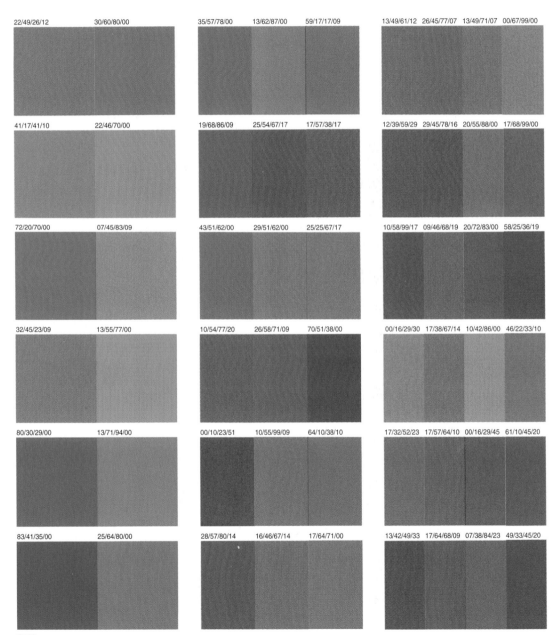

The Yellow Family

The yellow family (fig. 373) ranges from a warm orange-biased yellow (00/40/99/00) to a cool green-biased lemon yellow (20/00/99/00). They are the brightest hues in the entire visual spectrum.

Associated with agreeable sunshine, yellow always has a pleasant mood. It is highly visible, and represents youthful energy, speed, and movement. Mixed with black, it turns greenish. With some orange content, it becomes golden and exhibits a feeling of luxuriance.

Figure 374 shows yellow in hue/value/chroma variations, forming monochromatic or analogous color schemes.

Figure 375 shows yellow working with other colors to achieve strong hue and value contrasts.

Figure 376 shows muted and darkened yellows working with other subdued colors.

373

167

00/26/87/14 00/10/99/00 00/20/99/40 00/17/99/00 00/17/99/00 00/22/99/20 00/20/99/10 00/00/99/00 20/20/99/00

32/42/99/03 10/00/99/00 00/20/99/20 00/30/99/00 00/00/99/00 20/50/99/00 38/38/65/00 14/30/72/00 00/16/99/00

07/14/61/16 00/25/99/00 00/00/67/49 00/16/99/00 07/25/91/52 14/20/81/14 00/00/99/00 07/12/81/07 00/00/99/26

10/14/45/16 00/00/99/14 10/41/90/20 00/13/86/10 00/14/00/30 28/25/49/14 07/12/81/28 00/25/99/12 06/25/93/14

00/14/99/49 00/10/99/00 10/19/90/42 00/22/99/54 00/14/99/13 00/25/93/20 00/33/99/22 16/25/57/28 00/25/57/20

00/20/99/80 00/26/99/16 10/39/90/20 00/25/99/10 14/20/99/42 00/12/42/30 00/00/99/26 00/25/99/12 00/12/61/32

00/99/99/00 00/10/99/00

00/65/03/16 10/00/99/00

99/25/00/00 00/25/99/00

99/00/99/00 00/00/99/00

99/68/00/00 00/10/99/00

99/99/00/00 00/26/99/16

22/99/00/00 00/17/99/00 00/17/99/00

00/99/99/00 00/30/99/00 00/00/99/00

57/00/99/19 00/16/99/00 00/30/86/10

99/48/00/99 00/13/86/10 00/14/00/30

99/00/38/00 00/00/99/00 00/14/99/13

99/14/00/00 00/25/99/10 00/13/99/00

00/99/99/00 00/20/99/10 00/00/99/00 52/00/99/00

38/99/00/00 13/99/00/00 00/32/99/00 00/16/99/00

93/30/00/00 00/00/99/00 00/25/99/00 99/42/00/00

99/41/00/00 03/99/80/00 00/25/99/12 17/00/99/00

26/78/00/07 00/33/99/22 00/29/99/00 55/00/99/00

64/99/00/00 00/57/99/03 19/41/99/07 99/41/00/00

20/36/45/06 19/20/57/14 59/23/45/12 28/39/48/13 28/39/70/13 43/33/20/32 38/45/77/20 20/30/90/26 29/30/45/28

20/36/30/15 19/26/51/14 71/23/65/12 25/42/74/14 41/41/99/13 33/33/20/12 38/38/65/00 29/39/90/00 29/30/54/13

19/48/51/14 19/36/52/14 43/23/99/25 20/41/99/13 43/48/68/13 65/16/39/10 16/28/58/20 25/22/86/17 16/41/77/12

39/36/49/06 20/36/65/06 14/32/58/23 26/35/54/13 00/14/00/30 30/33/54/22 30/42/26/17 16/28/58/33 06/25/93/14

48/30/33/19 39/45/99/03 36/46/14/23 10/19/90/42 36/54/68/16 61/48/83/00 22/46/99/14 16/25/57/28 35/48/99/09

28/52/48/13 29/43/67/00 30/64/64/12 36/54/91/19 14/20/99/42 19/33/93/20 30/48/46/13 41/51/71/07 65/54/83/00

The Green Family

The green family (fig. 377) ranges from a yellowish green (40/00/99/00) to a bluish green (99/00/50/00). Yellowish green is a relatively warm and bright color. Bluish green is relatively cool and slightly darker.

Yellowish green is the color of new leaves. Thus it suggests springtime and symbolizes infancy, juvenility, freshness, and liveliness. Bluish green is the color of calm water, and has association with cleanliness and tranquillity. The standard green reminds us the color of summer leaves, gives a feeling of wilderness, healthiness, or mature growth.

Figure 378 shows a variety of greens in warm/cool, light/dark, and brilliant/dull changes, forming monochromatic and analogous color schemes.

Figure 379 shows greens working with other colors of relatively strong chroma.

Figure 380 shows muted greens working with other muted colors to establish quiet color schemes.

377

171

99/00/99/00 99/00/50/00

54/00/29/35 80/25/70/00 80/25/99/00

70/00/68/22 59/00/52/25 74/00/25/17 99/00/99/00

99/16/57/13 99/00/80/00

23/00/83/38 52/00/80/16 52/41/58/16

75/28/99/09 99/10/77/00 99/00/99/22 99/00/49/28

57/25/99/10 40/00/99/10

57/00/99/19 54/00/99/35 68/04/51/20

54/30/99/09 75/30/74/09 75/41/35/09 99/00/48/07

57/25/67/10 99/00/60/00

71/29/45/04 39/04/41/26 39/04/99/20

87/10/45/09 87/10/99/06 68/32/75/17 32/32/75/17

60/00/60/40 40/00/99/00

99/00/38/00 71/41/65/04 70/40/99/10

55/19/54/25 39/32/62/38 51/32/62/17 99/00/99/13

83/25/68/00 25/09/99/26

99/00/58/10 42/09/99/20 88/09/99/10

99/00/72/13 58/00/52/16 58/00/23/36 71/00/39/19

172

00/99/00/00	99/00/50/00

62/99/00/00	80/25/70/00	57/39/99/09

00/20/99/00	04/45/99/00	74/00/25/17	99/00/99/00

00/99/99/00	99/00/80/00

23/00/83/38	52/00/80/16	99/35/00/00

30/93/00/00	99/10/77/00	99/00/42/00	99/49/00/00

99/00/00/13	40/00/99/10

57/00/99/19	99/00/40/00	00/54/99/00

54/30/99/09	59/70/00/00	75/41/35/09	67/00/86/13

99/99/00/00	99/00/60/00

00/26/99/00	99/10/74/00	39/04/99/20

00/65/99/00	87/10/99/06	49/14/99/00	00/99/99/10

00/45/99/00	75/00/99/00

00/70/99/00	99/00/99/07	70/40/99/10

00/32/99/00	00/39/99/09	99/00/99/00	99/00/41/00

86/49/00/00	25/09/99/26

23/97/00/07	42/09/99/20	99/00/57/00

00/41/99/00	71/00/99/00	99/00/51/00	00/10/99/00

32/49/74/00 99/00/50/00

39/04/19/41 80/25/70/00 17/57/19/17

45/32/62/06 32/55/64/06 68/28/68/03 23/32/62/06

32/49/49/00 62/22/72/00

39/59/33/09 64/13/43/09 49/35/58/13

30/52/58/13 99/10/77/00 59/52/58/13 64/32/83/06

62/61/48/00 75/32/87/00

17/36/33/20 42/16/55/20 68/04/51/20

39/72/58/00 75/30/74/09 75/41/35/09 39/42/58/13

36/67/84/00 84/00/54/10

67/51/13/13 39/04/41/26 67/04/29/23

87/10/45/09 87/20/84/00 81/58/41/00 32/32/75/17

70/29/25/17 48/22/70/12

99/00/38/00 74/19/80/00 26/55/81/00

35/59/68/00 57/39/71/04 70/16/65/00 35/52/77/00

17/57/32/12 25/09/99/26

70/41/32/00 52/39/75/00 52/57/71/00

46/64/41/00 58/00/52/16 58/00/23/36 46/64/74/00

174

The Blue Family

The blue family (fig. 381) ranges from a greenish blue (99/00/25/00) to a purplish blue (99/99/00/00). The entire range has a dominant presence of cyan in all the different color mixtures. It encompasses what we sometimes refer to as turquoise, cerulean, ultramarine, indigo, and navy blues.

Greenish blue is the color of the sea or ocean. Basically a cool color, it feels relatively warm when compared with what we consider a standard blue, the coolest color in the visual spectrum. Blue is the color of the sky. Purplish or darkened blue is associated with coldness, night, conservativeness, infinity, and probably also dignity.

Figure 382 shows a variety of blues in warm/cool, light/dark, and brilliant/dull changes, forming monochromatic and analogous color schemes.

Figure 383 shows blues working with other colors of relatively strong chroma.

Figure 384 shows grayish blues working with other grayish colors in subdued color schemes.

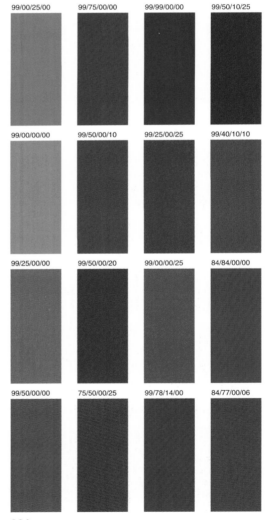

381

83/83/00/00 99/41/00/04

75/51/20/00 99/07/20/16 50/50/00/19

90/65/00/03 68/59/00/20 99/19/00/20 78/03/14/25

70/48/29/00 99/22/00/00

68/59/00/10 99/20/25/16 97/55/25/00

54/16/06/25 99/00/38/00 99/10/00/07 99/00/13/00

99/50/00/00 70/68/00/00

70/68/12/10 97/41/12/10 99/26/20/00

81/48/00/20 58/17/20/32 99/41/00/00 99/10/23/00

75/30/20/00 99/00/00/00

74/62/00/03 80/46/03/00 84/68/10/00

99/54/09/00 99/51/00/00 68/68/13/00 99/54/26/00

96/00/25/17 99/39/00/07

99/36/54/00 80/70/03/00 80/70/30/03

97/46/38/00 70/77/26/00 97/55/00/00 97/59/42/00

96/17/10/17 99/62/00/00

67/45/00/23 99/70/03/03 80/80/00/00

81/77/00/00 99/39/04/00 97/46/32/00 87/64/04/00

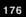

176

00/99/99/00 99/23/00/00

22/99/00/00 99/48/00/00 99/75/00/00

99/00/87/00 00/00/99/00 83/72/00/00 99/19/00/03

46/72/00/00 99/00/25/00

00/70/99/00 99/75/00/00 99/57/00/00

13/99/00/00 00/99/99/00 74/58/00/00 83/83/00/00

00/50/99/00 99/50/00/00

00/99/99/00 99/39/00/00 99/00/23/00

00/67/99/00 00/96/46/00 86/29/00/04 74/74/00/00

99/00/99/00 99/75/00/00

99/00/35/10 42/87/00/00 99/48/00/00

03/99/80/00 06/86/00/13 99/00/25/14 99/52/00/00

00/17/99/00 99/99/00/00

99/00/99/00 99/00/10/07 99/17/00/10

14/93/00/00 04/94/19/00 75/75/00/16 99/14/00/14

42/90/00/00 99/20/00/07

00/00/99/00 99/26/00/00 84/84/00/00

99/10/36/10 28/88/00/00 91/48/06/03 58/67/20/00

177

61/61/25/00 70/17/28/20

22/32/38/30 99/07/20/16 45/32/38/20

45/14/00/32 23/32/39/32 67/67/43/00 78/03/14/25

71/45/57/00 57/12/09/25

45/57/38/20 58/32/38/26 97/55/25/00

54/16/06/25 45/30/22/20 67/52/10/00 51/51/59/00

62/41/03/17 99/43/39/00

58/41/20/17 58/23/30/17 32/46/59/16

41/64/58/00 88/36/43/00 62/62/28/00 54/54/59/00

86/86/43/00 99/61/25/03

30/48/26/26 61/39/09/26 99/00/13/23

42/17/39/29 45/30/00/30 68/46/00/16 12/29/12/35

12/23/26/52 55/33/10/30

30/48/26/22 59/17/22/23 68/43/22/12

38/35/38/36 65/33/00/33 58/43/20/26 12/29/29/41

32/42/33/23 67/19/25/29

68/26/22/12 67/39/33/10 23/32/42/25

38/59/38/19 70/70/28/00 80/48/14/14 38/35/38/33

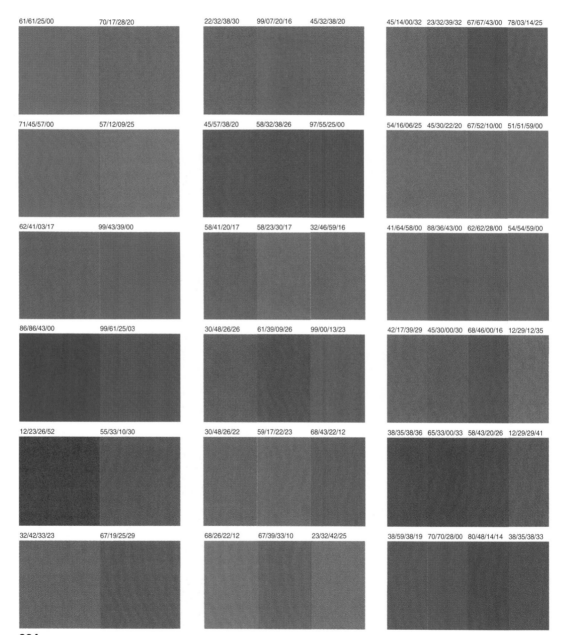

178

384

The Purple Family

The purple family (fig. 385) ranges from a bluish purple (75/99/00/00) to a purplish magenta (25/99/00/00), with colors formed with a high content of magenta and varying proportions of cyan. They generally represent the darkest colors in the visual spectrum. Chroma of the colors is reduced with the presence of yellow in the mixture.

Purple has been an expensive pigment for a long time. Thus it stands for royalty and nobility. Leaning towards magenta, it shows a feeling of feminine elegance, with romantic overtones, particularly when lightened in value.

Figure 386 shows purples with warm/cool, light/dark, and strong/dull variations forming monochromatic or analogous color schemes.

Figure 387 shows color schemes featuring purple working with other colors of relative strong chroma.

Figure 388 shows grayish purples working with other grayish colors in subdued color schemes.

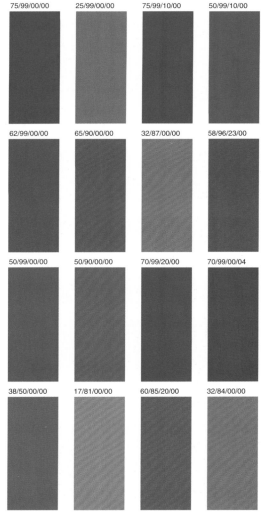

385

179

29/99/00/00 67/80/00/00

72/83/10/00 42/99/00/00

28/83/14/06 57/80/00/00

59/72/29/00 30/80/00/00

33/48/00/00 64/99/00/00

33/99/00/13 39/65/00/00

57/64/20/00 30/77/00/00 46/77/20/00

26/78/00/10 57/96/00/00 77/67/00/00

58/62/45/09 41/78/41/00 41/78/00/16

64/94/00/00 32/99/00/00 54/78/20/10

22/67/20/10 65/80/58/00 45/75/00/00

51/62/48/12 49/99/00/00 33/65/23/19

35/67/28/12 71/77/14/00 52/71/32/04 35/81/00/04

35/59/28/04 62/71/00/00 51/84/00/04 48/62/00/00

48/57/30/09 33/62/00/00 65/93/00/00 33/62/32/00

65/52/00/00 57/67/00/00 65/59/41/00 33/72/20/00

29/67/00/06 54/77/00/00 33/99/00/00 33/72/43/00

54/67/00/06 54/96/00/06 32/70/00/00 55/91/00/00

94/00/99/00	64/87/00/00
00/09/99/00	58/99/00/00
00/99/99/00	58/80/00/06
00/51/99/00	49/77/00/00
00/99/22/00	74/91/00/00
86/35/00/00	41/81/00/00

99/00/38/00	42/77/00/00	77/77/00/00
00/14/99/00	41/90/00/00	72/97/00/00
00/30/88/00	77/65/00/00	51/81/00/03
00/64/99/00	42/77/00/00	62/57/00/00
45/00/99/00	32/72/00/00	64/67/00/00
99/00/99/00	58/71/00/00	41/83/04/00

00/99/61/00	00/62/99/00	64/77/00/00	75/71/00/00
96/00/43/00	77/00/99/00	41/74/00/00	25/81/00/00
96/00/99/00	99/14/38/00	77/64/00/00	29/97/00/00
77/00/99/00	99/00/51/00	55/86/00/00	52/70/00/00
99/00/26/00	26/26/99/00	64/77/00/00	41/87/14/00
00/97/20/00	00/97/84/00	58/88/00/00	64/71/00/00

181

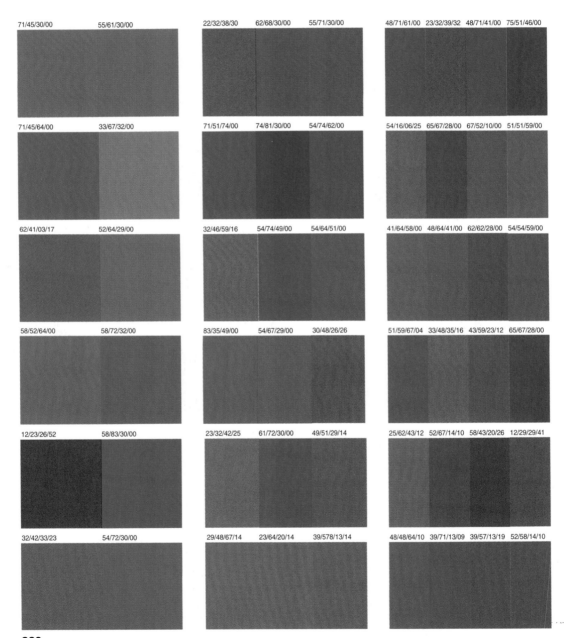

71/45/30/00 55/61/30/00 22/32/38/30 62/68/30/00 55/71/30/00 48/71/61/00 23/32/39/32 48/71/41/00 75/51/46/00

71/45/64/00 33/67/32/00 71/51/74/00 74/81/30/00 54/74/62/00 54/16/06/25 65/67/28/00 67/52/10/00 51/51/59/00

62/41/03/17 52/64/29/00 32/46/59/16 54/74/49/00 54/64/51/00 41/64/58/00 48/64/41/00 62/62/28/00 54/54/59/00

58/52/64/00 58/72/32/00 83/35/49/00 54/67/29/00 30/48/26/26 51/59/67/04 33/48/35/16 43/59/23/12 65/67/28/00

12/23/26/52 58/83/30/00 23/32/42/25 61/72/30/00 49/51/29/14 25/62/43/12 52/67/14/10 58/43/20/26 12/29/29/41

32/42/33/23 54/72/30/00 29/48/67/14 23/64/20/14 39/578/13/14 48/48/64/10 39/71/13/09 39/57/13/19 52/58/14/10

The High Key Colors

Pale colors and pastel colors all belong to the high key category. Such colors express softness, tenderness, and light-heartedness. They also give the feeling of openness, peacefulness, and relaxation. Yellow tends to display greater saturation than other colors in this range.

Figure 389 shows a range of high key colors of varying hues and chroma.

Figure 390 shows color schemes consisting of all high key colors, with hue and chroma contrasts but little value contrast.

00/00/80/00	00/16/52/00	00/29/30/00	00/25/00/00
26/33/00/00	25/25/00/00	35/15/00/00	40/00/00/00
30/00/30/00	19/09/38/00	20/17/33/00	17/28/33/00
22/35/23/00	17/38/20/00	36/22/09/00	36/12/26/00

389

00/10/40/00 00/30/40/00

14/22/28/00 17/16/29/00 35/00/39/00

17/32/54/00 41/19/46/00 35/17/65/00 13/41/46/00

32/13/13/00 00/36/13/00

14/39/06/00 14/22/41/00 36/23/06/00

42/12/17/00 13/35/17/00 16/22/67/00 35/00/46/00

28/13/36/00 20/26/03/00

00/00/68/00 17/00/57/00 36/00/30/00

03/39/13/00 14/19/38/00 14/06/55/00 33/16/35/00

17/00/42/00 00/16/42/00

17/30/29/00 17/23/46/00 00/10/83/00

03/22/32/00 00/36/25/00 12/38/12/00 41/16/12/00

26/26/00/00 38/00/00/00

00/33/57/00 19/33/45/00 19/42/16/00

12/25/43/00 38/00/19/00 14/10/39/00 30/10/26/00

00/33/00/00 13/17/39/00

39/14/46/00 39/25/16/00 17/32/42/00

17/32/09/00 00/46/04/00 20/36/26/00 30/28/26/00

184

390

The Intermediate Key Colors

Most hues of considerable saturation belong to the intermediate key category. Working in the intermediate key, one can explore a much wider range of brilliant colors to achieve the effect of exuberance and colorfulness.

Figure 391 shows a range of colors in this key with varying hues and chroma.

Figure 392 shows color schemes consisting of all intermediate key colors, with hue and chroma contrasts but little value contrast.

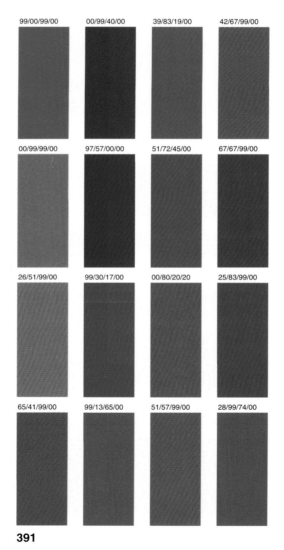

391

185

42/67/99/00 00/90/99/00

75/83/00/00 00/90/99/00

99/54/00/00 10/99/50/00

74/42/99/00 13/87/99/00

61/28/99/00 00/43/99/17

28/51/99/00 00/70/99/10

99/42/00/00 00/90/99/00 99/10/46/00

48/91/00/00 00/99/16/00 23/93/00/00

57/00/99/19 00/72/99/00 90/00/75/00

99/33/10/00 00/52/99/10 00/99/80/00

99/00/38/00 00/16/62/30 15/81/43/00

99/00/99/00 13/00/99/38 00/99/90/00

13/46/65/16 88/00/65/12 00/99/99/00 99/33/10/00

12/61/48/12 13/99/00/00 13/23/97/26 83/00/70/00

03/72/80/12 28/94/00/00 00/99/80/00 67/61/00/00

99/41/00/00 03/99/80/00 99/00/70/00 15/81/43/00

00/94/55/00 99/29/29/00 00/65/20/17 99/03/61/00

00/70/71/10 88/29/61/00 00/58/99/10 55/74/00/00

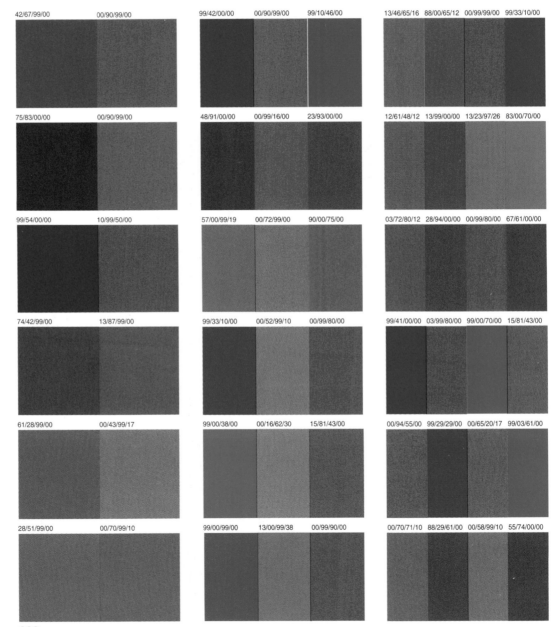

The Low Key Colors

Blues and purples can maintain much greater saturation than other hues in the low key category. Low key colors generally suggest mysteriousness and introspection, and might create a melancholic mood.

Figure 393 shows a range of low key colors of varying hues and chroma.

Figure 394 shows color schemes consisting of all low key colors, with hue and chroma contrasts but little value contrast.

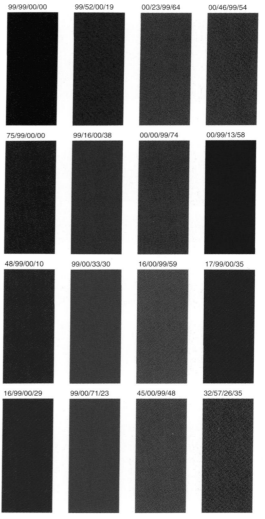

99/99/00/00 99/52/00/19 00/23/99/64 00/46/99/54

75/99/00/00 99/16/00/38 00/00/99/74 00/99/13/58

48/99/00/10 99/00/33/30 16/00/99/59 17/99/00/35

16/99/00/29 99/00/71/23 45/00/99/48 32/57/26/35

393

29/99/00/26 99/99/00/00

99/49/00/20 16/83/90/20

51/43/90/20 22/99/13/17

99/00/65/29 99/75/00/00

00/93/04/55 99/51/00/26

54/70/74/14 78/00/04/55

29/99/00/26 26/29/20/46 99/75/00/00

22/54/62/28 99/75/00/00 03/70/14/36

22/43/99/28 22/49/49/28 52/13/64/33

87/36/70/10 48/91/00/10 87/67/00/10

99/23/99/10 99/23/00/29 70/75/10/10

09/99/00/32 70/12/94/32 84/84/00/00

52/81/22/00 87/36/99/00 83/72/00/00 99/09/00/25

52/81/72/07 13/94/61/23 99/51/33/09 83/83/00/00

99/71/09/09 00/99/00/38 33/38/99/42 00/41/99/45

00/41/09/58 91/64/09/17 91/29/68/17 91/51/33/17

91/28/19/25 91/07/61/25 39/58/10/25 49/26/77/29

39/20/32/41 17/20/65/49 17/41/29/41 06/22/86/54

188

The Earth Colors

The earth colors include browns and ochres, and colors that have been mixed with some brown or ochre. Pigments that produce such colors are generally inexpensive as they are from the earth. They have a special character and could stand as a category of their own.

Earth colors are deep, rich, warm, and folksy, and are generally in the middle and dark keys. They range from rusty oranges, dark golds to bronze yellows, and olive greens to dark browns (fig. 395).

Figure 396 shows color schemes consisting of earth colors with hue, value, and chroma contrasts.

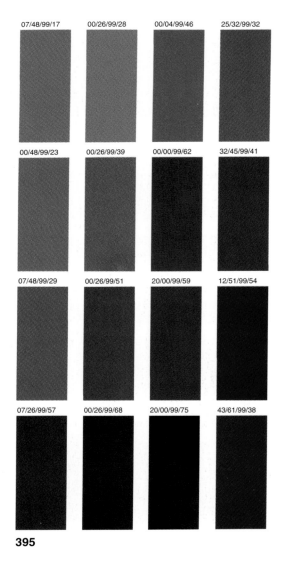

395

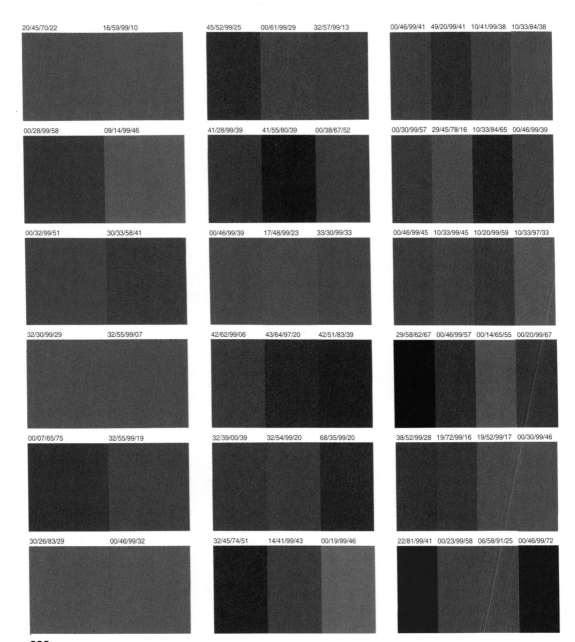

The Near-neutrals

The near-neutrals are grays that carry a slight touch of cyan, magenta, yellow, or their mixtures (fig. 397). They may be seen as warm grays, cool grays, or grays of some color inclination.

Their combinations can suggest the feeling of quietude, sobriety, somberness, sophistication, sadness, and nostalgia. They can establish the subtlest color schemes with minimization of value contrast (fig. 398).

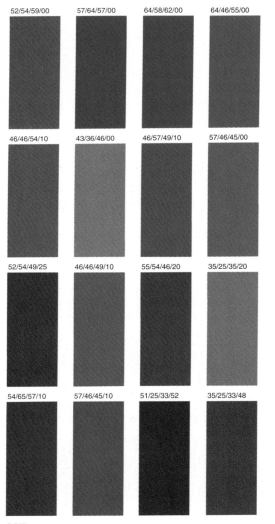

397

Incorporating Blacks, Whites, and Grays

Black is the darkest color. It stands for the total absence of light. It is the most used color in printing. Forming part of a color scheme, it does add a sense of solidity, stability, and masculinity (fig. 399).

 White is the brightest color. It suggests expanse, cleanliness, and purity. The presence of white helps lighten up the entire color scheme (fig. 400).

 Grays occupy intermediate steps between black and white. They represent the feeling of uncertainty, quietude, and inactivity. They tend to neutralize harsh contrasts between colors (fig. 401).

 In general, blacks, whites, and grays can all work harmoniously with chromatic colors, and add crispness and clarity to a design (fig. 402).

00/00/00/99 90/57/00/00 00/17/99/00 00/00/00/99 30/29/96/07 30/43/43/20

00/99/99/00 00/00/00/99 99/00/99/00 00/36/99/00 00/99/99/00 00/00/00/99

00/00/00/99 03/72/80/12 99/00/65/07 00/36/68/26 80/75/00/00 00/00/00/99

00/23/99/00 57/99/00/00 00/00/00/99 03/99/80/00 00/99/00/00 00/00/00/99

00/00/00/99 00/94/55/00 00/25/38/55 99/25/29/17 00/00/00/99 00/68/38/12

35/64/99/10 29/46/36/23 00/00/00/99 99/00/00/10 00/00/00/99 00/49/86/12

399

00/00/00/00 90/57/00/00 00/17/99/00 00/00/00/00 30/29/96/07 65/32/88/19 00/00/00/42 90/57/00/00 00/17/99/00 00/00/00/54 86/45/00/00 17/51/39/19

00/00/00/00 65/99/00/00 99/00/99/00 00/13/99/00 00/99/99/00 00/00/00/00 00/80/99/00 00/00/00/72 99/00/99/00 00/36/99/00 00/99/99/00 00/00/00/48

00/00/00/00 00/70/99/00 99/84/00/00 00/36/68/26 80/75/00/00 00/00/00/00 00/00/00/62 03/72/80/12 99/61/00/00 00/36/68/26 80/75/00/00 99/00/00/59

00/23/99/00 57/99/00/00 00/00/00/00 00/59/99/00 04/99/77/00 00/00/00/00 00/23/99/00 00/77/99/00 00/00/00/59 94/35/30/00 00/99/00/00 00/00/00/65

00/00/00/00 99/51/00/00 12/30/99/62 42/99/00/09 00/00/00/00 99/00/99/00 00/00/00/62 00/94/55/00 16/99/00/00 72/00/12/30 00/00/00/45 00/68/38/12

26/38/88/42 29/46/36/23 00/00/00/00 00/00/00/00 97/00/48/17 00/49/86/12 00/00/35/49 29/46/36/23 00/00/00/46 99/00/00/10 00/00/0049 00/49/86/12

400 **401**

00/00/00/00	00/23/99/00	00/99/99/00	00/00/00/99
59/99/00/00	00/00/00/77	00/00/99/33	00/00/00/99
59/99/00/00	00/00/00/00	00/43/99/00	00/00/00/67
00/45/99/32	00/00/00/00	00/00/00/99	99/00/00/00
00/00/00/70	13/99/00/00	00/99/50/00	00/00/00/99
83/00/99/00	00/00/00/67	00/00/99/90	00/00/00/00
00/00/00/99	15/81/43/00	00/00/00/00	99/00/48/07
00/00/00/77	00/00/99/99	00/99/80/00	99/00/48/07
00/00/00/78	00/19/99/36	00/00/00/00	67/00/99/00
99/41/00/00	03/99/80/00	00/00/00/00	00/00/00/99
00/14/99/33	03/99/80/00	00/00/00/71	00/00/00/99
99/00/00/00	00/22/99/00	00/00/00/84	00/00/00/00
00/99/99/00	00/00/00/99	00/32/99/00	00/00/00/00
00/00/00/71	99/00/99/00	00/00/00/99	55/00/99/00
00/58/99/00	00/00/00/00	49/00/33/33	00/00/00/80
16/52/77/20	00/00/00/99	00/00/00/00	99/83/00/00
00/00/00/99	00/00/00/50	32/64/00/20	00/52/99/00
00/00/00/00	00/00/00/51	00/38/99/33	00/99/99/00

195

USING THE COLOR GUIDES

Each color combination in the color guides may be used with or without modification to form a color scheme for a particular design. We can pick colors from two color combinations (fig. 403), attribute color to shapes, and the alter background in different ways for different effects (figs. 404–409).

404

403

405

406

408

407

409

We can even choose colors from several color combinations (fig. 410) to form a new combination, which is then used for the design (figs. 411, 412).

411

54/30/99/09 75/30/74/09 75/41/35/09 99/00/48/07

10/58/99/17 00/71/99/12 26/64/59/00 22/48/48/22

26/78/00/07 00/33/99/22 00/29/99/00 55/00/99/00

410

412

Varying Values, Hues, and Chromas

For greater clarity, we can increase value contrast among the colors (figs. 413, 414). To achieve extremely subtle color expression, we can have all the colors as close in value as possible (fig. 415). We can vary hues (figs. 416, 417) and chromas (figs. 418, 419), with or without value changes, to attain desirable effects.

414

413

415

416

418

417

419

Using Type in Black, White, or Color

Black and white could form part of the color scheme. For small type to be legible, black is often the most effective (fig. 420) unless the background on which type appears is rather dark. White type on colored areas may lose sharp definition due to probable off-registration of various color layers (fig. 421). For large type, white can be a good choice (fig. 422). Type in color requires adequate contrast in value, hue and/or chroma to be visible, legible, or both (figs. 423-426).

421

420

422

423

424

425

426

Adding Outlines

Color shapes and type may be stroked with outlines of desirable weight. Outlines can be in black, white, gray, or in color, and can significantly alter color contrasts and the general character of the design (figs. 427–429).

428

427

429

203

INDEX

INDEX

command
 blend, 131
 duplicate, 127
composition, 3, 16, 32, 61, 78, 94
 formal, 3, 10, 11, 12, 18, 81
 informal, 3, 14, 18, 81
 semi-formal, 10
contrast, 14, 16, 31, 37, 59, 65, 69, 70,
 81, 82, 89, 193
 chroma, 46, 52, 61, 93, 183, 185, 187,
 189, 201
 complementary, 70, 90
 hue, 50, 51, 65, 77, 82, 85, 86, 90,
 163, 167, 185, 187, 189, 201
 simultaneous, 53, 54, 61, 74, 89, 90
 tonal, 26
 value, 52, 61, 93, 167, 183,185, 187,
 189, 191, 199, 201

D

depth, 20, 62, 66, 70, 74, 78
dilation, 3, 10, 13, 81
direction, 4, 6, 8, 10, 12, 16, 19, 62, 70,
 119

E

edge, 4, 6, 15, 59, 81, 117, 121, 125
eight-digit code, 146, 149
ending, 6

F

family
 blue, 175
 green, 171
 orange, 163
 red, 159
 yellow, 167

feathering, 117
fill
 gradient, 135
 radial, 135
form
 super-unit, 66

G

gamut
 CMYK, 145
 RGB, 145
gradient, 133
gravity, 3, 14, 15, 70
grayscale, 109
grid, 11, 66, 77, 78

H

halftone, 29
 dots, 146
 pattern, 106
hue, 33–36, 39–43, 45–51, 53, 55, 59,
 69, 73, 74, 78, 89, 93, 138, 139,
 143, 149, 151, 159, 163, 167, 183,
 185, 187, 199
 analogous, 51, 69, 77, 89, 90, 93
 basic, 43, 45, 89
 complementary, 50, 53, 54, 77, 81, 82,
 89, 90, 93, 94
 contrasting, 77
 gradations, 45, 46, 52, 69, 70, 73, 81,
 86
 near-complementary, 50, 77, 89
 primary, 43, 45, 46, 50
 secondary, 43, 45, 46
 split-complementary, 77, 89, 90
 unrelated, 85, 86, 89, 93, 94